digital travel photography

digital travel photography

Dan Heller

LARK BOOKS
A Division of Sterling Publishing Co., Inc.
New York

Editor: Haley Pritchard
Book Design and Layout: Tom Metcalf
Cover Designer: Thom Gaines
Editorial Assistance: Delores Gosnell and Dawn Dillingham
Associate Art Directors: Lance Wille and Shannon Yokeley

Library of Congress Cataloging-in-Publication Data

Heller, Dan.
 Digital travel photography / Dan Heller. — 1st ed.
 p. cm.
 Includes index.
 ISBN 1-57990-973-6 (pbk.)
 1. Photography Digital techniques. 2. Image processing—Digital
techniques. I. Title.
 TR267.H44 2007
 775—dc22

 2006036753

10 9 8 7 6 5 4 3 2 1

First Edition

Published by Lark Books, A Division of
Sterling Publishing Co., Inc.
387 Park Avenue South, New York, N.Y. 10016

Text © 2007, Dan Heller
Photography © 2007, Dan Heller unless otherwise specified

Distributed in Canada by Sterling Publishing,
c/o Canadian Manda Group, 165 Dufferin Street
Toronto, Ontario, Canada M6K 3H6

Distributed in the United Kingdom by GMC Distribution Services,
Castle Place, 166 High Street, Lewes, East Sussex, England BN7 1XU

Distributed in Australia by Capricorn Link (Australia) Pty Ltd.,
P.O. Box 704, Windsor, NSW 2756 Australia

If you have questions or comments about this book, please contact:
Lark Books
67 Broadway
Asheville, NC 28801
(828) 253-0467
www.larkbooks.com

Manufactured in China

ISBN 13: 978-1-57990-973-4
ISBN 10: 1-57990-973-6

For information about custom editions, special sales, premium and corporate purchases, please contact Sterling Special Sales Department at 800-805-5489 or specialsales@sterlingpub.com.

foreword

As a travel photographer, my job is to go on trips that tour companies sell and take photos for their catalogs. I am sent along to capture everyday tourists enjoying the activities and sights that the trip has to offer. As I get to know the other trip members, it's not long before I'm asked what the secret is to taking the kind of pictures that end up in catalogs.

The challenge in answering that question is to think of ways to explain a complicated subject to someone who's looking for a simple answer. Indeed, I know this first hand because, before I was a professional photographer, I wondered the same things. I met one pro on a trip that was particularly influential in his attitude about the subject. When I asked him what the "secret" was, he replied, "Everything I know about photography I learned by looking at other people's pictures." This was the inspiration that finally hit home with me. I'd always thought there was so much more to it, that there were real photography "secrets" out there, or that the key to good pictures was expensive photo equipment. Once I realized this wasn't the case, I started looking more closely at photos in catalogs, magazines, online websites, and so on, looking for the key to good pictures in the pictures themselves.

I had a strong desire to become a better photographer, so I put a lot of time and effort into improving my photographic eye. However, many people out there want to take better pictures without investing so much time. The vast majority of travelers with a camera in tow don't want to be photo students, they just want quick notes on what they can do to take better pictures.

In an effort to offer some guidance to travelers of this mindset, I've come up with the book you're reading now. I discovered that there is a middle ground between teaching photography and helping people get better pictures. As a result, the primary goal of this text is to offer you some easy photography methods that will yield the best results in the shortest amount of time, and that require little effort. By following the guidelines put forward here, you will bring home much better vacation photos than you used to.

While there is some technical information to grasp—let's face it, you need to know how your camera works to make the most of it—nothing here is so complex that it can't be absorbed by even the most novice of beginners. The bulk of this book focuses on the simple technique of associating an image with its attributes, and having those attributes explained in detail in the text so you can know what to look for yourself. Yes, looking at other people's photos really does help.

In that spirit, the most important aspect to taking better pictures is simply composition. As the first chapter discusses, composition is not only the most important part of a photo, but it's also the part in which you have the most control. Well-composed photos are rarely ones that you'll throw away, whereas even a photo of a fantastic sunset or a great smile on a child's face can find its way to your computer's trash bin if the composition is off. Good composition is knowing how to see as the cameras does.

As for photo equipment, another misperception people have is that they need high-end photo gear. This is not the case. In fact, any point-and-shoot digital camera sold today is capable of taking great shots. Not so long ago in 2000, when Fujifilm was just entering the low-end digital camera market, I was asked to use their 2.3 megapixel cameras to shoot demo pictures for their brochures. So there I was, on a major assignment, my high-end photo gear hanging on my back in a huge backpack while I took pictures with a tiny point-and-shoot camera. And you know what? The pictures I got with that little camera came out just as good as the ones shot with my big, expensive film camera. Of course, my choice of subjects was much more limited with the point-n-shoot, simply because it wasn't capable of many kinds of shots, so the kind of pictures I got were largely restricted to traditional daytime landscapes, cityscapes, and posed people pictures. The moral of the story, though, is that if you learn how to see what the camera sees, you can use almost any camera to take descent pictures. All that said, if you're in the market for buying a new camera, the primary drawbacks of point-and-shoots that you won't have with a digital SLR are:

• Limitations on slower shutter speeds (no long exposures)

• No cable release for tripod use (poor interior architecture shots)

• No "wide angle" shots

• Limits on fast shutter-speeds (for sports or action shots)

• Lengthy shutter lag times (making candid shots difficult)

• Extremely poor on-camera flash capability

In short, point-and-shoots limit your creative options and often your ability to get the shot you really want. While they will do the trick for the average tourist, keep in mind what your limitations may be. In the chapter covering photo equipment, I'll get into more detail about these issues and we'll discuss some options if you're in the market for buying new digital photography equipment.

So, as you begin reading this book, pay most attention to the photos themselves and the quick tack notes that accompany them. We'll cover everything from compositional basics to how to approach strangers in a foreign country to take their photos. I'm confident that you'll be surprised how much easier digital travel photography really is than you ever thought.

Dan Heller

digital travel photography

I admit it, I have a cushy job. I get paid to take the pictures of spectacular vacation spots that you see in magazines or travel catalogs. What can I say? It's a living, and someone's got to do it.

Besides wondering how you could get a job like that, you're probably also thinking to yourself, "Just how hard can it be?" And you're not alone. Early in my travels, one particular tourist made the following observation: "If you put a great-looking model on a pristine beach on a beautiful day, and just sit there and snap a million pictures with great photo equipment, even a monkey could come up with great shots." That tourist was me. And the photographer who was on assignment for that trip replied, "So, why aren't you taking a million pictures?"

I sat and pondered that for a while. What if I actually did just shoot indiscriminately as my theory suggested? Would I suddenly find gold nuggets among them? Back then, I would typically bring two or three rolls of film for a two-week vacation, and even then I would only finish all the rolls if the weather was good. Nevertheless, I was determined to test my theory on my next vacation, a two-week cycling trip to New Zealand. I packed what I thought was far more film than I ever thought I'd use: ten rolls. 36-exposures each. And with my point-and-shoot camera, I exhausted my supply precisely to the last day. And what was the result of all my indiscriminate shooting? I got a lot of bad pictures. But, I also learned an important lesson that applies just as much to digital photography as it did to film: a good photo is rarely accomplished without effort.

Placing your subjects up front and off center is appealing compositional technique.

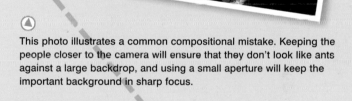

Composition: The First Step to Better Pictures

This photo illustrates a common compositional mistake. Keeping the people closer to the camera will ensure that they don't look like ants against a large backdrop, and using a small aperture will keep the important background in sharp focus.

Clearly, my theory needed rethinking. I was convinced that there couldn't be much more to photography than what I observed. I thought, "What is it that these pros do that I'm not doing?" While it's true that pros tend to have better equipment, I knew it was more than that. I thought maybe it was a matter of having better technical skills, which is certainly an important aspect of good photography, but the problem with my poor images wasn't bad exposures. This got me to look more closely at some of those magazine photos of wonderful places.

That's when it hit me: I noticed composition choices I hadn't seen before. I saw that composition can truly make or break a photo. The kind of images that casually please our eye as we flip through travel brochures and magazines are pleasing to us because the photographer paid attention to his or her composition; using a window to frame a landscape rather than just taking a scenic wide-angle picture; placing friends in the immediate foreground rather than far away next to

the ancient cathedral; zooming in close on people, rather than holding back. Yes, even small, subtle things, like making sure the horizon (and/or other lines in the scene) are level can have a dramatic effect on the perceived quality of an image.

My big epiphany came when I started really seeing as my camera sees, not as my eyes do. Looking at a scene with a photographic eye is profoundly different than the way we normally observe the world around us. Our brains are wired to see things in relation to time, three dimensions, and live-action movement. We then interpret all these things and have our own unique emotional and physical reactions to them. When we click the camera's shutter release, we think the camera is capturing the same impression that our brains are, but it doesn't. Reproducing that same emotional effect requires understanding how to look at a real world scene with a photographic eye.

A typical tourist shot might be of friends or family members lined up like a football team in front of an ancient cathedral, and that tourist might be thinking, "Hey! People I know! An old church! We're in Spain! We're having fun! Let's take a picture to capture the moment!" Then later when he or she looks at the photo on the computer or prints it out for placement in the trip photo album, the overall sense is that the image just doesn't capture the same essence of the moment that the photographer had hoped it would.

So, how do you get the shot that you really want? Let's imagine that we're looking at some failed vacation photos and try to discern a few key things that will improve your pictures right off the bat. Viewing a photograph allows the brain to pick up details that might not have been as obvious when your eye was pressed to the viewfinder and you were focused on your subject; telephone wires overhead, or that annoying red car that snuck into the edge of the frame. When we see pictures, we notice all these small artifacts and imperfections that we often had no idea were even there in the first place when we took the shot. Learning to look for distracting image elements at the time you're actually taking the photo is a good first step towards tightening up your composition.

The second thing our real-time brains are wired to do that our photo-viewing brains don't is automatically interpreting lines in a scene as horizontal or vertical if they are not very obviously diagonal. Think about it. We always see the horizon as a level horizontal line, or the side of a building as vertical, even though they may actually be tilting in one direction or the other depending on our vantage point. Our real-time brains also compensate for jittery motion, as well as being able to conceptually focus on an object of our interest no matter what other distracting elements surround it. Our real-time brains also put objects' sizes in perspective to one another, such as the size of a full moon in a dark sky, or the proximity of a friend standing next to a statue far away. Our real-time brains even do color-correction, compensating for the color cast of an indoor tungsten bulb or a red sunset, for example, so that we can still see colors normally. And yet another adjustment we make is for light; most of us can see fairly well in a dimly lit room, and our eyes automatically adjust if we walk out of that room and into bright sunshine.

This string of mental perceptions and compensations, however, does not translate to the camera. Our brains work overtime to construct a reality that makes sense to us, but the camera does not interpret light like we do unless we do things like tell it there's a color cast, lengthen the exposure to compensate for low light, or tilt the camera in one direction or the other to straighten out horizontal or vertical elements in the scene. We have to use our brains to guide the camera, and we must see the shot we're about to take with a photographic eye that looks for elements that might detract from capturing the scene at as close to a "real life" view as possible. Now, this is not to say that you shouldn't get creative with your photography and specifically aim to capture a scene in a surreal way on occasion, but this section is meant to awaken you to some of the most common ways that our eyes and brains fool us into ruining what we intended to be a realistic shot.

Good composition is easier than you think. Training your eye to balance the scene in the viewfinder and remove distracting elements just takes some practice.

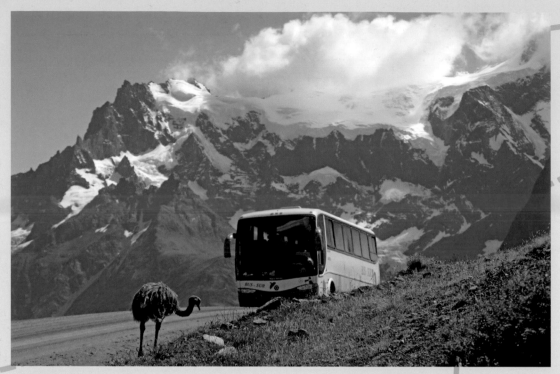

▲ Do you really want that bus in the background?

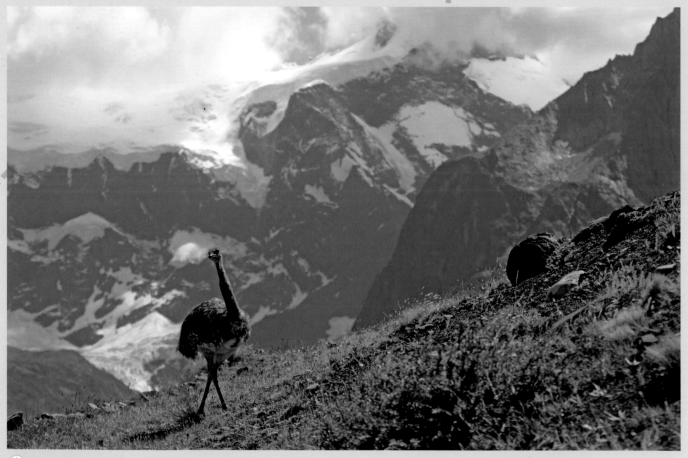

▲ Move a few steps to the left and place the mountains behind the subject. A new vantage point can make all the difference.

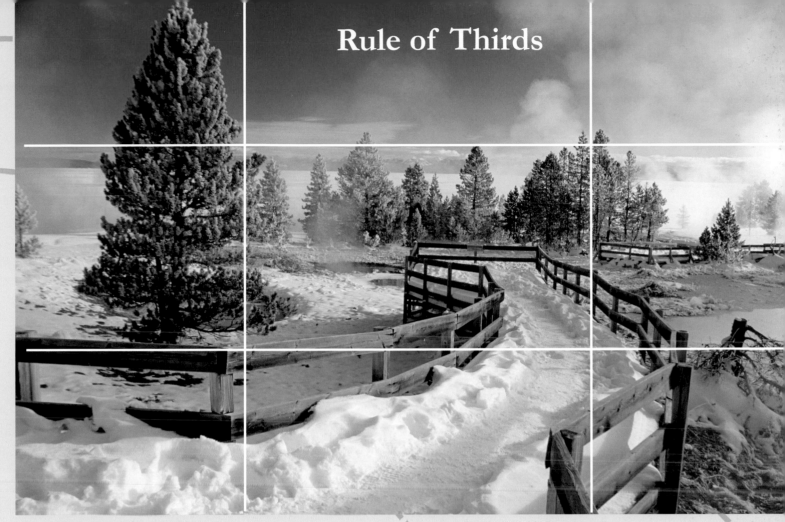

In this photo, you can see that the horizon and parts of the fence line up with the rule of thirds' horizontal grid lines, and the tree in the foreground lines up with the leftmost vertical grid line.

The Rule of Thirds

Though it can certainly be dissected and studied, good composition is largely intuitive; with just a bit of effort, you can easily see what works and what doesn't. This introductory chapter is simply a tool to help you train your eye to see what your camera sees. By keeping in mind the things we've discussed here, you will soon discover that your pictures have improved considerably. Along that vein, there is a simple compositional technique called the rule of thirds that you can use to improve almost any shot.

When composing a picture, the rule of thirds can promote most any average photographer to the next level almost instantaneously. The idea is to break down the scene into thirds, both horizontally and vertically. Strong horizontal ele-

ments should line up with (or be close to) either the top or bottom division lines in the frame. Similarly, strong vertical elements should line up with the right or left division lines in the frame.

Some digital cameras have grid lines in the viewfinder that can be turned on or off, but with most cameras, you will have to use your trained eye to imagine a grid over the scene and place scene elements accordingly.

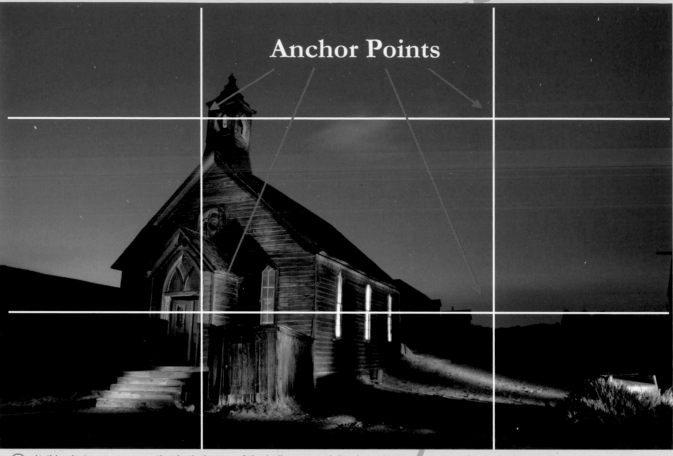

Anchor Points

In this photo, you can see that both the top of the bell tower and the doorway are near an anchor point.

Anchor Points: The four cross-sections where each of the dividing lines intersect are called anchor points. These spots are good references points for placing objects in the scene, such as a doorway, a car, a light, or a person.

Practice taking a series of photos using the rule of thirds and the corresponding anchor points, but don't ever feel restricted by them. It may be called the "rule" of thirds, but it is really only a guideline, and it is always subjective to the creative judgment of the photographer—you. Not every anchor point needs an object, and not every scene has a horizon. Learning to balance a scene by imagining that it's divided into horizontal or vertical thirds may seem involved when you first try it out, but it doesn't take long before it becomes second nature and you don't even think about it anymore.

Summary

A large part of the learning process is simply trying things out and seeing what works best for your style of shooting and the kind of pictures you want to take. When it comes to creating a winning composition, once you know what to look for, you can bring that knowledge to the viewfinder and examine the scene with a photographic eye. Take the time to do as much practice shooting as you can at home before you leave for your trip so that you can really let your new photographic perspective sink in. Then, take your practice pictures, upload them into your computer, and examine each of them with a critical eye. Even though you can glance at your camera's LCD monitor to get a sense of whether you got the shot, the tiny screen is a poor representation of the image, and only examining it at full size on your computer or in print will enable you to judge for yourself whether the shot was a success.

Many websites allow you to upload pictures and have other people review them. Any good search engine will quickly find the latest and greatest sites for this if it interests you. And even if you're not ready to show your art to the world, you might gain some interesting insights by examining other people's work and seeing what other viewers had to say about it. Reading other people's critiques (and the critiques of those critiques) will quickly let you see your own photos with a new eye.

Let's Get Technical

I shot this image at f/9 and a shutter stop of 1/128 with a Canon EF 28-135mm lens. Now, what did you learn from that? Knowing the technical details of a particular shot may be interesting, but they won't tell you much.

Okay, so this is the part where I remind you that a good photo isn't entirely about good composition. There are some technical details involved, especially for complicated shots. And while those who fear tech-talk are probably more squeamish than they need to be, those who seek technical details tend to rely on it far too much, thereby failing to be self-sufficient. Therefore, I'm hoping to reach a happy medium here. Let me illustrate.

I frequently receive emails about my photos that include the following question: "What were your camera settings when you took that picture? It would really help me to know that, because I'm a beginner." When I read something like this, it always reminds me of the story where Ansel Adams was teaching a photo workshop in Yosemite National Park and a student raised his hand and asked, "What was the aperture setting and shutter speed on that photo of the moon rising over Half Dome?" Ansel quickly replied that it was f/64 at 2 seconds. This prompted another student to ask the same about another photo, to which Ansel again offered his exact camera settings. This apparently went on for quite some time while the students scribbled down all the technical information he gave out, as if a magician were giving away his secrets. Finally, someone asked, "How do you remember all that information?" This time, the answer was more direct: "I don't. I'm making it up." The pencils stopped, and all eyes looked up. "Beginners always wonder about this information, but it's meaningless. When you learn how to shoot, it won't even occur to you to ask such questions, or to remember those settings yourself."

A lot of beginners mistakenly believe that knowing the camera settings for any given picture will help them learn something, or give them some guidelines or insights on how the photographic process works. But photography is not about memorizing these kinds of details and applying them under what appear to be similar conditions. One cannot possibly learn anything using this method. In my opinion, books that provide such information do more harm than good by perpetuating the illusion of knowledge, thereby delaying the real learning process.

When I talk about technical matters in this book, I'm not going to spoon-feed you useless data that you need to regurgitate in the field to come up with a similar picture. Instead, I'll only use particular apertures and shutter speeds to illustrate a photographic effect I'm trying to explain. In every case, technical discussions are intended to be general guidelines about the nature of the process, not information to be stored for later retrieval.

Expect to Do Some Image Processing

The eye-popping photos that you see in books, galleries, and magazines these days are rarely the original images that came out of the camera. So, although camera technology is getting better by the minute, you shouldn't be discouraged if your photo of that gorgeous sunset doesn't come out as spectacularly as the scene appeared in real life. This isn't your fault; our eyes simply see more dynamic colors and wavelengths of light than a camera is capable of seeing. So, while the camera does a great job representing real-world light in those everyday, evenly-lit daytime scenes, all cameras begin to falter when the light gets complex, uneven, or brighter or darker than the typical middle range of light.

Don't worry, though. This little predicament isn't as bad as it might sound. Most of the time, with a little effort on your part, your camera will do a pretty nice job. For those few situations where you really feel like something is lacking in the photo, there are image-processing software programs galore (i.e., Adobe Photoshop Elements, ACDSee, Kodak EasyShare, etc.) to help you tweak your images to your liking. Maybe the image just needs added contrast. Perhaps the skin tones of your subject have an unwanted color cast that you'd like to correct. Whether you want to enhance the natural colors you remember from the scene or add more surreal colors or effects to bring out a certain mood, image-processing programs have a wide array of options to suit your needs. Delving into specific programs or functions here is beyond the scope of this book, but the Internet is a great tool for researching what options are available to you. And don't be concerned if you've never used a program like this before; whether you're a novice or a pro, there's a program out there for you.

As I said, this book does not delve into specific software programs or image-processing functions, but it is mentioned here to let you know what to expect in terms of your own photography and what options you have for improving it post-capture. Granted, you may well be perfectly happy with your unedited prints when you get them back from the lab, but there may also be a time when you try a shot found in this book and say, "I did exactly what you did, but you got all that shadow detail that I didn't." Trust me, it's not you or your camera; it's the post-processing. If you want to take digital photography to the next level, find an image-processing program that suits your needs and skill level. (No, it's not cheating—it just gives you the option of making a good picture great.)

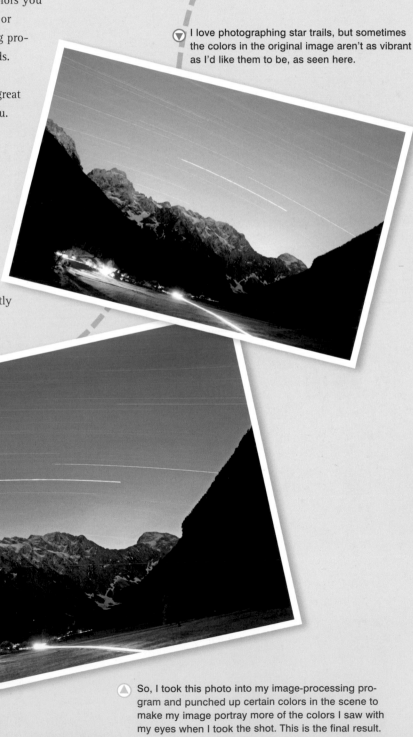

I love photographing star trails, but sometimes the colors in the original image aren't as vibrant as I'd like them to be, as seen here.

So, I took this photo into my image-processing program and punched up certain colors in the scene to make my image portray more of the colors I saw with my eyes when I took the shot. This is the final result.

Learning the Ropes, Gaining Perspective

I present no photographs here that require technical facts or skills that aren't described sufficiently for you to accomplish successfully on your own. If you ever find that a technique or process described here makes you feel a bit intimidated, let me put another thing into perspective: Even the pros rarely get the shot "right" the first time, or at all in some cases. Though some pictures really are just single shots, it's more often the exception than the rule. One needn't master technical skills before making good pictures. Over time, you will simply get better at taking pictures. The more familiar you are with your camera and equipment, and the more photos you take, the easier digital photography will become.

On the other end of the scale, there are certainly those who are well adept at using their camera, and accordingly, may be worried that this book might be too simplistic. Again, learn from the Ansel Adams story (on page 26)—it's not about the details, it's about the process. Those who are already comfortable with their technical ability are great candidates for one of the main objectives of this book, which is stepping away from the technical side of photography to gain a greater perspective of what makes a good picture. This book will most assuredly be a good guide for anyone from the beginner to the moderately advanced amateur photographer.

In closing, let's return to my own early observation about travel photography (on page 18) and re-evaluate it. Given a great-looking model, a pristine beach, a sunny day, and great photo equipment, can "anyone" can come up with great photos? I can honestly say, yes. All it really takes is a little effort to be conscious of the scene you see in the viewfinder and some practice at training your photographic eye. Spend some time practicing on a beach with your family or friends the next time you're on vacation and you'll see just what I mean. Gaining confidence in your photography will then allow you branch out and try things that might seem a little trickier, such as photographing star trails (which I discuss in detail on pages 113-118).

getting equipped

Going on vacation and just bringing a camera for fun? Or, is photography your main objective and you're hoping to land a great photo of a stunning sunset in Venice, Italy? However casual or serious you may be, choosing the right photo equipment for travel photography is critical. You should expect to do research on current product offerings from resources that specialize in equipment review and analysis if you're in the market to buy new equipment. Top national newspapers and other consumer periodicals have websites that contain up-to-date columns written by reviewers who know and understand you, the target audience. Also, Internet search engines are great for finding such resources.

Contrarily, and odd though it may sound, professional photographers are not likely to be a good resource for equipment suggestions. If you ask a pro what kind of camera to buy, for example, they're likely reply with something like, "Well, it depends on the kind of pictures you want to shoot." This is the first sign that you're speaking to someone that hasn't been around non-professional photographers in a long time. (In fact, I never advise people what to buy; I only explain what things do and how they work.

So, reading equipment reviews is a good place to start. Once you're informed about a subject, the next step is to seek advice from other photographers like you. Internet search engines come in handy again here. Look for discussion forums where people talk about their experiences with various products. I often refer people to www.dpreview.com and www.photo.net, both of which are reputable photography information websites.

Reading and participating in discussion forums is especially good for getting a general feeling for whether particular products are considered worthwhile from people who have no vested interest in promoting them. And as I mentioned already, it is important to get opinions from peers, not professionals. A pro may have a stinging review of a product because it doesn't offer what he or she needs, but that same product may be perfectly suitable for your needs. In light of that, be careful about reading too much into the information on discussion boards. There is a lot of misinformation out there, as well. When you feel like you've gathered enough information to narrow your choices down, go to a camera store and check out the equipment in person. Nothing beats holding something in your hand and putting it to the test.

Camera Bodies

For even the most modestly interested amateur photographer, D-SLR (digital single-lens-reflex) cameras will provide far more pleasing results than point-and-shoot cameras will. They provide more creative control, not to mention the advanced technology and flexibility to open up your photo opportunities beyond the standard daytime snapshot. That said, I don't entirely dismiss the classic point-and-shoot camera. These cameras are still quite powerful, and are becoming more so every day.

If you are looking to purchase new equipment, it is imperative that you do so well in advance of any travel you have planned. It's very hard to learn new equipment on the road. If anything goes wrong, your options and resources for solving the problem are limited.

Batteries

Nothing's worse than losing battery power when you're about to take a picture, and since digital cameras eat batteries faster than a golden retriever can nab toast off of a baby's high-chair, it's most imperative that you're prepared with enough "juice" to keep your camera going. The best thing you can do is study your camera's manual to understand each of the following battery issues intimately:

Which Batteries Can Your Camera Use?

Almost all digital cameras use rechargeable batteries, but some will also take standard AA batteries that you can buy in any store. Other cameras, however, not only won't use those standard batteries, but using them may actually ruin your camera. If you're in a pinch and need to get emergency power, be sure you know what your alternate battery power options are by reading about them in your camera's operating manual.

How Many Pictures Can You Take per Battery Charge?

There are many variables involved in this question, such as whether you use a flash (and how often), the frequency with which you use the LCD monitor screen to examine and edit pictures, and so on. Hands-on experience with your camera is the only reliable way to answer this question for yourself. Many newer cameras have battery status monitors that will tell you how close you are to needing a battery recharge.

Does Your Charger Have a Built-In Voltage Converter?

One important pitfall to be aware of (particularly if you area using a point-and-shoot camera) is that, if you plan to travel to foreign countries that don't use the same electrical voltage you have at home, you may not be able to recharge your batteries if your camera's power supply doesn't have a voltage converter.

Learn How to Conserve Batteries

Most low-end point-and-shoot cameras do not come with power converters. Be sure to read your manual to see if your camera does or not. If you don't have your manual, you can easily tell whether your power supply has a converter by checking the power cord for a variable voltage range, such as 110 – 220v. If it only lists a single number like 110v or 115v, or if it doesn't even have a cord (such as one of those chargers that plugs directly into the wall), then you're almost assuredly don't have a converter.

For those who are using a D-SLR, this problem is usually a non-issue. Nearly all of them include voltage converters as part of their power supplies. So for these cameras, a simple adaptor that converts one plug type to another is sufficient for international travel.

Many cameras' manuals will describe which functions eat more battery power than others. If battery conservation is important due to travel constraints, this information could be critical. Some of the most common battery draining activities are use of the LCD monitor screen for reviewing and editing images, frequent use of the flash, long exposure times, and continuous shooting (where the camera takes several photos in rapid succession up to its maximum frames per second—fps—rate).

Understand Your Travel Itinerary

If you're going to be roughing it in the wild, on safari, trekking across mountains, diving or snorkeling, or spending significant time in extreme temperatures, prepare by buying enough extra batteries to last between the times when you will be able to recharge. Batteries notoriously lose power quickly in cold weather, but they gain it back when warmed up again. If you're going to be in the snow, for example, have two sets of batteries that you can swap in and out of the camera and a pocket close to your body so that when the batteries in the camera get cold you can switch them out for the warmer ones. If you are going to be out in the wild for several days and won't be able to recharge, you will likely want to have more than just one backup battery. Here again, experience shooting with your camera and your style will guide you in your decision when determining just how much extra battery power you might need. And if your travel plans involve prolonged exposure to the cold, be sure to compensate with more battery power than you would need otherwise.

Digital Camera Sensors and Megapixel Resolution

The sensor is the most important part of a digital camera; it is what actually records the images. How well it does this largely governs the quality of your pictures. Fortunately, sensor technology has evolved to the point where even the most mediocre cameras can take good photos for the casual vacationer, but there's no need to settle for cheap; you can often get much better technology without a huge incremental jump in cost.

A digital camera's resolution is determined by the number of megapixels (millions of pixels) on its sensor surface. Just about every camera sold today has enough resolution to produce acceptable photo prints, so how do you know how many megapixels you actually need to get the quality photos you want? The truth is that even a four- or five-megapixel camera will likely offer you enough picture quality to make decent photo enlargements for a photo album or frame. However, if you invest in a six-, eight-, or twelve-megapixel camera, you will never have to wonder if you have enough resolution to crop your images just the way you want them and still retain adequate resolution for prints and enlargements. The more resolution you have to work with, the more options are available to you when it comes to cropping and making prints.

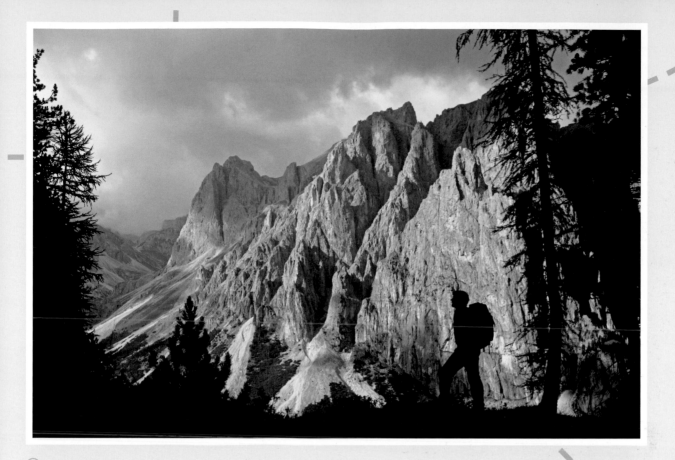

Sensors come in two general sizes: A few cameras have sensors that are the same size as a frame of 35mm film, and are called "full-frame" sensors. Any sensor that is smaller than this falls into the second size category of "small-format" sensors. These result in an effective field-of-view crop because the sensor covers a smaller area.

The Magnification Factor

With the exception of a few D-SLRs, most digital camera sensors are smaller than a 35mm frame of film. This is important to understand if you have purchased or plan to purchase a D-SLR with a small-format sensor, as any lens you place on it will function at a higher effective focal length (reduced field-of-view) than it would on a camera with a full-frame sensor.

Imagine you have two cameras set up to take the same shot, each the same distance from a subject, each with lenses of equal focal length. One camera has a small-format sensor, and the other has a full-frame sensor. The small-format sensor is about two-thirds the size of the full-frame sensor, so when you compare the two photographs the cameras have taken, the small-format sensor will have captured slightly less of the scene than the full-frame sensor did. The resulting image from the small-format sensor looks zoomed in, or cropped, compared to the view captured by the full-frame sensor. This effect is referred to as "the magnification factor."

To make this understandable to photographers used to shooting with film SLRs, magnification factors are used, such as 1.5x or 1.6x. This is intended to convey a translation for lens focal length from the lens' original field of view to its effective focal length (or field of view) when used on a D-SLR with a small-format sensor. Using the 1.6x example, a 100mm lens will produce a photo that looks like it was taken with a 160mm lens on a 35mm camera; a 400mm lens shoots like a 640mm lens; a 28mm lens shoots like a 35mm lens, etc.

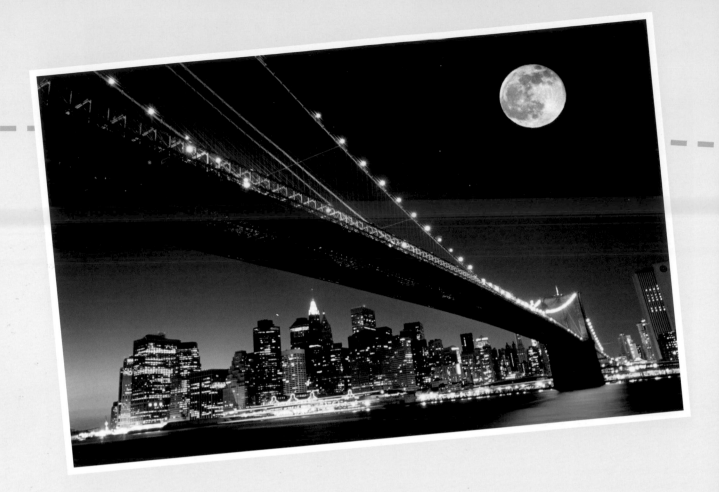

Keeping Your Sensor Free from Debris

One of the most frustrating things you may encounter with a D-SLR camera is when dust gets on the sensor. (This is not a problem with digital point-n-shoot cameras because the lenses don't come off, making the interior chamber dust-proof.) As you might imagine, the risk of dust getting on the sensor occurs mainly when you change lenses, so my first and most important suggestion is that you should change lenses in a way that minimizes the time the chamber is exposed. In addition, try changing the lens with the camera body facing down; this will also help reduce the risk of any particles falling into the lens chamber.

Even following these careful lens-changing techniques, however, it is still possible that dust particles will reach the sensor. You can often tell this is the case if you start to see the same array of specks repeated in your pictures. The natural tendency is to clean the sensor, but resist this temptation as it is fraught with various problems:

• It is very easy to damage the sensor (voiding your warranty). Camera manufacturers don't provide sanctioned tools for doing it yourself.

• Compressed air only makes matters worse because it can project particles that damage the sensor or deposit liquid byproducts onto it.

• Brushes can bring in more dust than they get rid of.

There are anti-static brushes made by some small-companies, but they have been met with mixed reviews. Highly vocal fans on photo discussion boards can be persuasive, but my experience with them has been mediocre. The best I can say is that they're better than cloth and compressed air, and good enough for removing very large chunks of debris. In truth though, your safest bet is to send your camera to a repair center that has been certified by your camera's manufacturer to perform sensor cleaning. This will ensure that you don't accidentally damage your sensor and void your warranty. In the meantime, you will just have to deal with the dust spots in your photos and rely on image-processing software to edit them out later in the computer.

Lenses

When it comes to getting the best possible pictures with your digital camera, a very close second in importance to the sensor is the lens. More expensive lenses do have better glass, but that doesn't mean that less expensive lenses can't take great pictures too. Unless you know that you "need" higher-end glass, there's no reason to stray too far outside your budget for the sake of your lens. The important thing is making sure that your lens covers the full gamut of focal lengths you want to be able to use to make your image captures.

For digital point-and-shoot users, this is especially important. Since your camera's lens is built into the camera body, you do not have the ability to interchange it with a lens of a different focal length range for specific shooting purposes. If you elect to invest in this style of camera as opposed to a D-SLR, make sure that your camera goes from a wide angle of 28mm (if not lower) all the way up to around 200mm. The broader the range, the more flexibility you'll have in picture styles. However, the broader the zoom range, the higher the price.

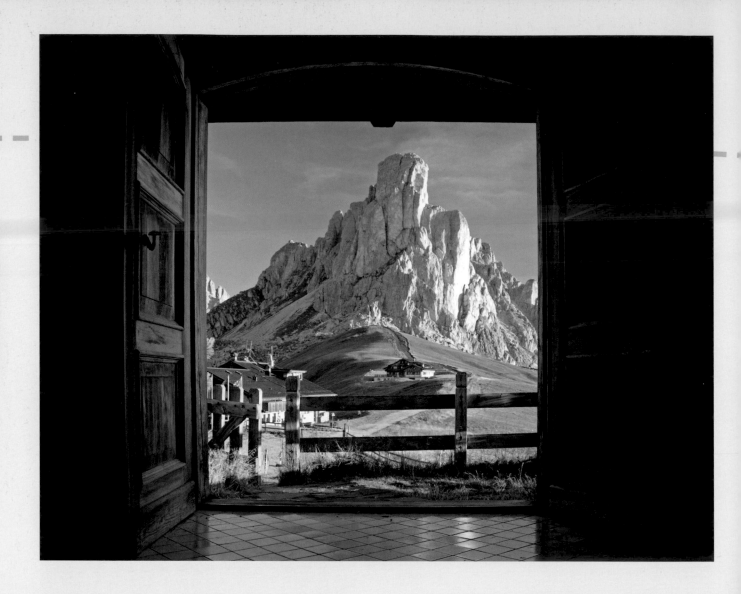

One thing to look out for is digital zoom. This is a useless and deceptive feature that merely zooms in on the available pixels and makes them bigger, thereby cropping any pixels that no longer fit in the viewing frame out of the recorded file. This almost always results in a noticeably lower-quality image. To avoid potentially serious image problems, use only the optical zoom on your digital point-and-shoot camera.

If you use a D-SLR with interchangeable lenses, digital zoom is not something you need to concern yourself with; it does not exist in the D-SLR world. Your lens options are greater with D-SLRs, too. That is, you can elect to buy a zoom lens with an extensive focal length range, or you can take that same ideal range and buy multiple lenses to cover subsets of focal lengths within that range. My equipment covers a focal range from 16mm to 400mm using three separate lenses: wide-angle, mid-range, and telephoto.

So why would you want multiple lenses when you can just buy one zoom lens that covers a significant range of focal lengths? Well, there are pluses and minuses to both options. There is a tradeoff between focal length flexibility and lens quality. The greater the zoom range in a single lens, the lower the quality of the image at each end of the focal length range. This is simply due to the laws of physics that relate to how mirrors bend light. The problem is reduced as the zoom range of the lens lessens, but having many shorter zooms requires having more lenses to lug around. So, there's your tradeoff.

Go to your local camera store and explore your lens options. Pick up a camera bag or photo backpack that has room for several lenses and see if the sales person will allow you to try it out. You may find that carrying multiple lenses is just not for you, but then again, you may also find that there are some nice photography gear bags on the market that will easily carry whatever equipment you need. In the end, it is a matter of personal preference. (See pages 64-67 for more information about camera bags.)

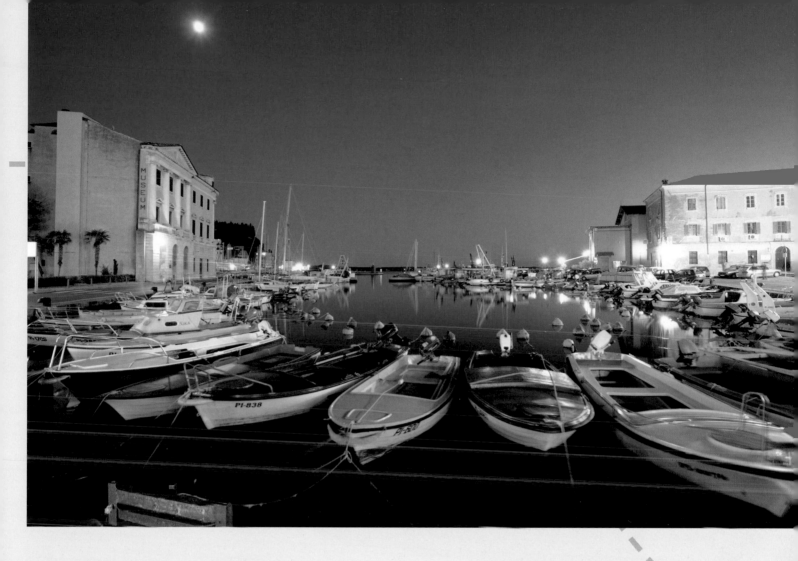

Wide-Angle Lenses

For me, my wide-angle lenses provide some serious competition to my mid-range lenses when it comes to usefulness; I like having a wider angle to capture the interiors of rooms, or to accentuate sweeping landscapes. In addition to the standard "wider view" capabilities, these shorter lenses also allow for wider apertures, which allow more light into the camera. This means you can shoot in lower light without having to use a tripod or increase your camera's ISO sensitivity setting.

The ISO rating on all digital cameras is user-selectable. The higher the setting, the more capable the camera is at shooting in low light. The cost of using higher ISO settings, however, is the introduction of digital noise in your photo, which diminishes image quality.

Mid-Range Zoom Lenses

Mid-range zooms are used in most common day-to-day situations: snapshots, candid people pictures, landscapes, pet photos, or anything else that looks best when viewed from a "normal" viewing perspective. Focal ranges span from 24mm to 200mm, which overlaps with what is considered wide-angle at the short end and with what is considered telephoto at the long end. Basically, mid-range zooms include the best of both worlds. The mid-range lens will be your main workhorse. If you only buy one lens—or if you can only bring one on your trip—this should be it. Prices go up as the focal length range increases, but lower-end off-brand lenses with extended focal length ranges tend to yield poor quality images, especially at the ends of the focal ranges. As with any lens purchase, it's important that you do your homework ahead of time. Read objective product reviews from people who have no vested interest in selling or promoting a product.

Fisheye Lenses

Fisheye lenses are extremely wide-angle lenses that are designed to offer creative distortion to the proportions of your image. As a specialty lens, I love the fisheye. I use it for everything from landscapes to people to general grab shooting, but it is important to keep in mind its inherent properties. It is not a zoom lens, so it can only shoot at a fixed distance. Also, it bends things out of proportion, so it is best suited for photos where you want to add humor or exaggerate some object or scene. Be aware, however, that the rules of composition apply here more than ever. In other words, make sure the picture is balanced and has a featured subject or theme.

Telephoto Lenses

Telephoto lenses are more versatile than most people think. Many people are familiar with the fact that they are great for wildlife and sports, but they can also be used for close-up photography, portraits, or candid shots of people in public places. Telephotos usually start at the low end anywhere from 80mm to 100mm and up to about 400mm before prices start skyrocketing. (In other words, extreme telephoto focal lengths are extremely pricey.) The best telephoto zoom range is 100-400mm, both for practical purposes and in terms of preservation of optical performance. Lenses with this range do tend to be pricier than their 300mm maximum focal length

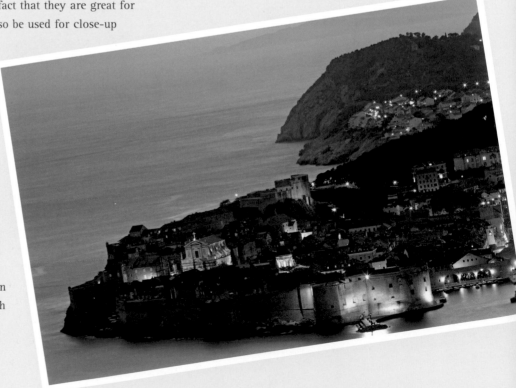

⬆ This photo was taken in Dubrovnik, Croatia with a 400mm telephoto lens.

counterparts, however. For most people, a maximum focal length of 300mm will satisfy your ultra-close zooming needs without sending your wallet into space.

The biggest concern with telephoto lenses is blur from camera shake. The longer the focal length you're shooting at, the more likely you are to get motion blur if you are hand-holding the camera. There are three ways to deal with this problem:

1. Use a very fast shutter speed. The rule is to use a shutter speed at least as fast as the reciprocal of the focal length you are shooting with. For example, if you are shooting at 400mm, you will need to use a shutter speed of 1/400 second or faster. Bear in mind, though, that you need to calculate in your sensor's magnification factor when making this determination. So, if your magnification factor is 1.6x and your lens focal length is set to 400mm, your effective focal length is actually 640mm. This means that in order to avoid camera shake you will need to use a shutter speed of 1/1000 second (as this is the next fastest shutter speed after 1/500 second, though some cameras do have the ability to create intermediary shutter speeds).

2. Even better, use camera support. It has been said that hand-held shots at any focal length above 300mm, no matter how fast a shutter speed you use, are still susceptible to motion blur from hand shake. If you are able to bring a light-weight tripod or a monopod with you on your trip, it may really come in handy for those long telephoto shots. (See pages 68-69 for more about camera support.)

3. The third solution is image stabilization technology. Often abbreviated to IS, cameras or lenses with this feature automatically compensate for camera movement to help you achieve a sharper image. Not only does IS help with shooting at long focal lengths, but it also enables you to use significantly slower shutter speeds than you would be able to otherwise. Image stabilization may well save 30 – 40% of pictures that would otherwise by ruined by unintended motion blur, so it is certainly worth looking into what options, if any, may be available for your particular camera.

The average person cannot produce sharp hand-held shots at shutter speeds slower than 1/60 second. However, image stabilization technology can enable some users to shoot at speeds as slow as 1/8 second with practice.

A Final Word on Lenses

While having multiple lenses to cover the entire focal length range may yield the highest quality photos, you may be restricted by factors such as weight, bulk, cost and convenience. Indeed, some travelers don't like the impracticality of having to change lenses. If you're not used to doing so, you may miss some great shots because you're fumbling with your lenses. If you have to limit your lens choices for any reason, I recommend that you at least be sure to bring a high quality mid-range zoom lens on your trip. A focal length range of 28-105mm is a common choice. Limiting your available focal length range to any less than that will hurt your pictures.

If you are using a point-and-shoot digital camera, the key points to remember are making sure that the built-in lens has an optical zoom range that covers all your wide-angle to telephoto needs and avoiding the use of any digital zoom feature, as it only degrades image quality. Some digital point-and-shoots have a screw mount on the front of the built-in lens that may allow you to use a filter mount or a fisheye attachment. Every camera is different, so be sure to review your instruction book and refer to the camera manufacturer's website for more information about additional camera accessories that may enhance your camera's lens capabilities.

Cleaning Your Lens

Keeping your lens clean is important, but not something to be obsessed about. It takes a lot of material on the lens glass to interfere with an image. (This is nowhere near as bad as dust on the sensor, which does show up conspicuously in images.) My main advice is to keep your lens cap on at all times in between shots. When you're about to take a picture, remove the lens cap, keep it in your hand, and immediately replace it when you're not shooting. Make this a habit.

If you do find that significant dust or debris is covering the lens glass, use a micro fiber cloth to gently wipe it away. You can find these special cloths at any camera store. In a pinch, you could use your shirt if it is a soft cotton fabric, but this is not ideal. Your shirt likely has additional dirt and debris on it that you may just wipe onto the lens. Plus, some fabrics may scratch the lens glass. There are some liquid lens cleaners available, but I tend to avoid these. The simplest thing to do is just to carry a lens cloth in your camera bag.

Exploring
Flash and ISO

The flash is probably the most misused item on a camera, though certainly for understandable reasons. The flash is a source of additional light, so the natural tendency is to use it anytime you're indoors or in other dimly lit situations. In many cases, this means that flash is used as the main light source, and that is precisely where the problem lies. The result is often flat pictures with overly bright subjects and harsh shadows.

Another common flash pitfall occurs due to the flash's limited range. An external accessory flash will have greater range than your camera's built-in flash, but even an accessory flash cannot always do the job when your subject is too far from the camera. At a concert or a theater performance, for example, it is unlikely that your flash will reach the subjects on stage unless you are seated in one of front-most rows.

Flash problems like these were much more serious for film photographers, but there is good news for all you digital camera shooters. One of the greatest features that all digital cameras share is the ability to change your ISO sensitivity at the touch of a button or the turn of a dial. In other words, if a scene is too dark for you to capture with available light, then you try using the flash and get poor results, your next best option is to increase your ISO sensitivity setting. The higher the ISO setting you use, the better the camera will respond to low-light situations.

Take these two images, for example. They are of the same low-light stage scene, but one was taken with a flash, the other with an ISO sensitivity setting of 800. Notice that, in the first picture, the flash's limited range caused the light to "fall off" quickly resulting in a poor exposure. Objects closer to the camera got the brunt of the flash burst, and everything in the background got progressively less light. Now look at the second image, captured with an ISO setting of 800; the use of a higher ISO allowed the camera to capture the scene using the available light, resulting in a much more natural looking photo.

52

You may be wondering, why not set the ISO all the way up all the time? There is a very simple answer: Higher ISO settings increase the amount of digital noise (unsightly specks of color) in the picture. You probably won't notice this on the camera's LCD preview screen, but you will notice it when you see the image enlarged on your computer monitor, as well as in the prints you make. Some cameras perform better than others in this regard, so take a couple of test pictures at high ISO settings to see how your camera deals with this situation. You may also want to compare shots of low-light situations with flash versus a high ISO. In some cases, you may prefer to use flash. Everyone's taste is different, so just explore your options so that you are comfortable enough with your camera's capabilities to decide on the spot how best to capture any tricky low-light scene you come across.

You may occasionally find that neither the flash nor a high ISO setting alone are sufficient for capturing the scene. In this case, you may want to try combining the two. If your camera (or accessory flash unit) will allow you to "dial down" the flash power, reducing the flash output is a good place to start. Then, experiment with increasing the ISO until you get the picture you want. The combination of a reduced flash burst and a higher ISO rating will often provide satisfactory results.

Never use a flash in front of reflective objects like windows.

High ISOs and Digital Noise

Try to shoot at the lowest possible ISO setting any given scene will allow. The higher the ISO setting you use, the more noise (grainy-looking specks) will appear in your image. Each higher ISO setting will contain successively more digital noise. Results vary among camera manufacturers, so familiarize yourself with your camera to determine where your tolerance lies for various lighting conditions and noise levels.

Flash Modes and Flash Power

Some cameras allow you to adjust flash power up or down. If yours does, experiment. The lower the flash's output, the more opportunity the natural light of the scene has to balance out the picture. Try reducing your flash exposure by one full stop (1 EV) to avoid the "bursty" snapshot look that plagues so many flash photos.

When to Use Fill Flash

Ironically, the best time to use a flash is not when it's dark, but when there's a lot of light, such as on a bright sunny day. Often times, very strong lighting causes dark shadows on your subject, and that is where fill flash comes in. If your subject is wearing a hat in bright sunlight, for example, using fill flash will light up the dark shadow that the hat brim casts over the subject's face.

When the sun is that bright, the light exceeds the camera's dynamic range, or the range of light that the sensor is able to see at one time. Your eye sees detail in the bright areas as well as the dark shadows, but the camera can't. The sensor's range is limited, which compromises its ability to capture the very bright and very dark areas of the scene. In so doing, it usually loses the detail in the darkest and lightest areas in favor of capturing the light in the middle of the range. This often means that dark areas fall to black and light areas fall

▲ Flash-free photos generally look better.

to white with very little detail at either end. Using fill flash will bring up the light on the darker parts of the picture, thus reducing the range of light between the two end points. Reducing the extreme range of light tones allows the camera sensor to capture more detail at both the dark and light ends of the light spectrum.

Fill flash isn't limited to people pictures, but it is particular to subjects that are close to the camera. Why is proximity important? Because the flash's light has a limited range, usually about ten feet or so in front of you. Beyond that, the power is too weak to have any appreciable effect. (This is called "light falloff.") When you notice dark shadows in your scene that could be brightened up with fill flash, just be sure that you are close enough to shadow areas for the flash to have an effect. You should also page through your camera's instruction book to see if it has a specific fill flash mode for these situations.

Warm Up the Light

Placing a an 81A or 81B filter over your flash "warms" up the bluish hue of the light that falls on your subject. If you don't have a filter, try a piece of clear tape (not masking tape) colored with a faint brown magic marker.

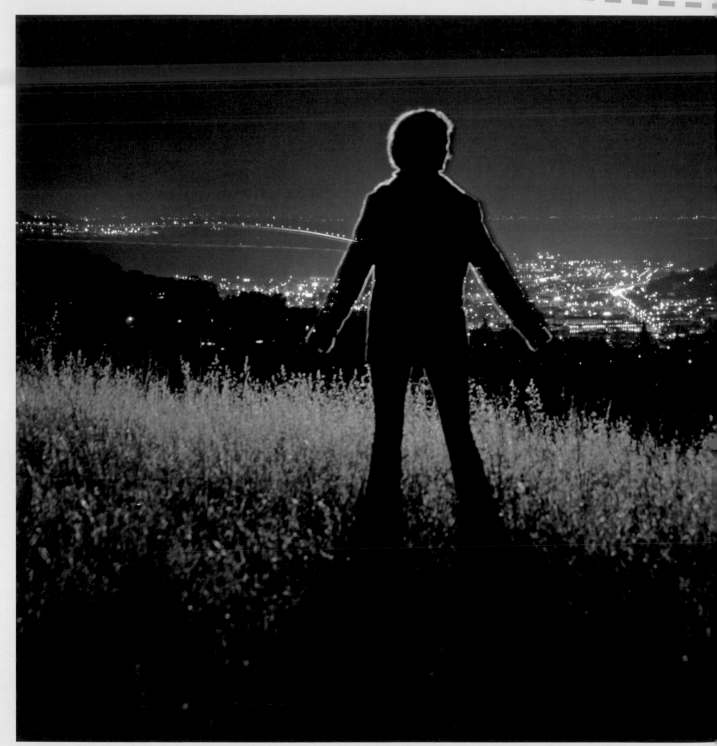

In the photo shown here, I set my camera's white balance to the indoor tungsten light setting, which tells the camera to shift the color hue toward blue to compensate for the red color cast of tungsten light. There wasn't any red color cast to compensate for in this scene, so the white balance setting just added blue to my image.

Understanding
White Balance

All digital cameras have a white balance feature that enables you to tell the camera what kind of light you are shooting in to optimize the colors in your image. Some of the most common white balance settings are for daylight, cloudy, shade, flash, fluorescent, and tungsten (indoor non-fluorescent light). Each of these lighting situations tends to color light in a certain way. Telling your camera what type of light you are shooting in by selecting the appropriate white balance option lets the camera know how to compensate for an overabundance of a certain color of light so that your images will have natural-looking color.

Conveniently, most cameras also have an automatic white balance setting. If you set your white balance to automatic, your camera will read and balance the color of light on a shot-by-shot basis, compensating when necessary. Indoor incandescent light bulbs, for example, often produce a reddish hue. Using flash can counterbalance this effect, but your camera's white balance feature will balance out the red tones in the image without the use of flash. With white balance set to automatic, the camera senses whether there is a predominant colorcast in the scene and adds a counter-balanced hue to compensate and produce truer color in your images.

Using White Balance for Creative Effect

As we just discussed, you can leave your white balance set to automatic so that it always aims to produce natural-looking color in your pictures, and you can also use the various white balance settings by name to tell the camera to react to the light in the scene a certain way. However, if you want to use color casts creatively to add interest or a certain mood to your photos, you can purposefully select a white balance setting that does not match the light in the scene.

You don't need a flash to get a great photograph at night. Instead, try mounting your camera on a tripod (or using some other stable surface) and use a long exposure time to capture the scene. I used a 30 second exposure for this photo.

Shooting at Night

Fill flash is great for close-up subjects in daylight, but it doesn't address how to shoot in very dark scenes where more light is necessary to take the picture than what the flash can provide. When traveling, you may find that you want to capture the bright lights of a city or a beautifully lit bridge against the evening sky. The scene may look bright enough to you, but it's not to the camera.

The best thing to do in this type of situation is mount the camera on a tripod and use a long exposure. If you don't have a tripod handy, look for a nearby wall or another stable surface, but be absolutely sure that your camera won't slip off before taking your hands away. Exactly how long of an exposure you should use to capture a particular scene will vary from shot to shot. Experiment for a few shots, lengthening the time you leave the shutter open bit by bit until you get the result you want. Remember, with digital it's as easy as reviewing the capture on your LCD monitor to see if you got the shot.

The trick to capturing stunning night scenes is the tripod keeping the camera still during the exposure. This will give you the "reality" look you're expecting to see. It's impossible to get this kind of look with a standard camera and flash burst. (For more information about tripods and other camera supports, see pages 68-69.) Using a tripod also eliminates the

need to increase your ISO sensitivity in these dark situations. (The only reason to increase ISO in low-light is so you hand hold the camera and still get the shot.) Use the lowest ISO setting you can, such as ISO 100, to avoid any digital noise from that end. Unfortunately, it is likely that you will get some digital noise simply from using a long exposure. This is common in most digital cameras. The longer the shutter is open, the more electricity runs through the sensor, which causes the noise.

If you're thinking that you can use a tripod to take pictures during a candlelight dinner, keep in mind that no one is going to remain perfectly still during a 10-30 second exposure. If this kind of creative motion blur suits your fancy, give it a try. Otherwise, you'll have no choice but to use some balance of higher ISO sensitivity and low flash power and hope for the best.

As you can imagine, there are going to be many pictures that cannot easily be taken, or that require techniques that aren't conducive to the situation at hand. In the end, you won't be able to capture every shot as well as you'd hoped, and some maybe not at all, but don't let that stop you from trying if you have the opportunity. Once again, digital comes through with the great option of reviewing your images and erasing the ones that didn't work out, so why not give it a try?

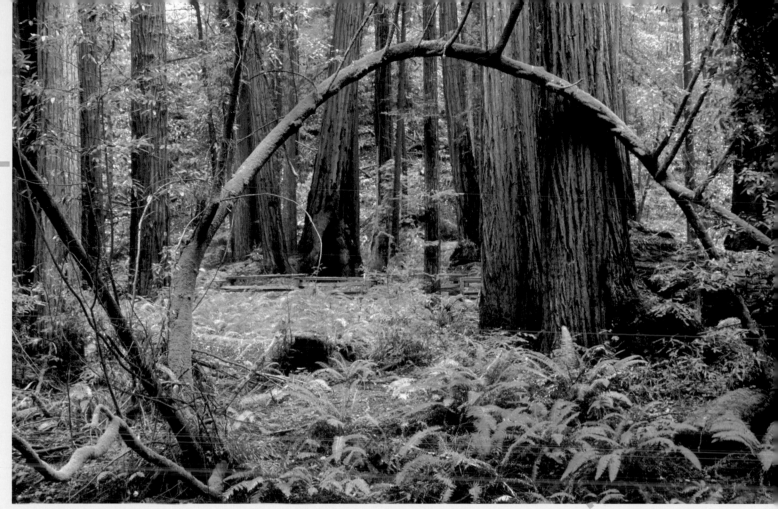

▲ Circular polarizers intensify color.

Filters

Filters are most commonly used with digital SLR cameras, but some advanced compact digital point-and-shoots have a screw mount attachment that enables the use of filters and other lens attachments, such as a close-up or a fisheye lens. In any case, the progression of digital photography has largely reduced the need for many of the more common filters used with film cameras. For example, the ever-popular skylight, haze, and UV filters were traditionally used to reduce the haze effect in daytime landscape photography. Nowadays, however, digital cameras compensate so well for color cast, as well as having built-in contrast and hue controls in many cases, that these filters are unnecessary.

Some people also suggest that skylight, haze, and UV filters can be used to protect your lens glass from scratches, but what you're effectively doing is placing very cheap glass (the filter) in front of expensive glass (your lens). And in my experience, general precautionary attention to your camera and

lens is what will really protect your equipment. Making it a habit to keep your lens cap on between shots is a good place to start.

All that said, there are still several very useful filters that I would like to discuss here. It is true that some of the visual effects created by the following filters can be replicated using image-processing programs on your computer, but why put the time and effort into image manipulation when you can use a filter to get the effect you want right from the moment you release the shutter? You should also make a point to familiarize yourself with all of your camera's various features and functions, as some digital cameras have in-camera digital filter options. In the end, whether your rely more on traditional filters or digital filters is a matter of personal preference, but being armed with enough information to make an informed decision is never a bad thing.

Circular Polarizing Filters

The circular polarizer is at once the most useful filter of all and the most misunderstood. You may be familiar with the fact that a polarizer can be used enrich colors, such as making daytime skies look bluer, but what you may not know is that the way this filter achieves that effect is what makes it so useful for other purposes, as well. Polarizing filters block reflected light. This reflected light is referred to as "polarized" light because it bounces in exactly the opposite direction as the direction it came from. In the process, light goes from a randomly erratic pattern to a very precise pattern, such as a crisp reflection in a window, and it is this pattern that polarizers filter out. Reflected light includes glare, reflections, highlights, and so on. This effect is found in more than just window reflections; you will likely encounter it with all sorts of shiny reflective objects, including skin, fruit, wood, and some fabrics. Polarizers block reflected light more or less depending on which direction you rotate the filter in its mount.

When you have reflected light bouncing all around, it dilutes the effect of the other light in the scene. Removing this unwanted light with a polarizer allows a higher concentration of the light and colors that you actually want into the exposure. Leaves appear greener, roses are redder, and as many of you already know, the sky is much bluer. In effect, you get a much richer color palette. A polarizer may not make a huge difference in every shot, but many pictures will look better with one than without.

Let's talk a bit more about exactly how a polarizer works so you can make the best possible use of it. Polarizers filter out light in 90-degree angles from the orientation of the filter, and because it's circular, you can rotate the glass to block out the specific polarized light that is distracting from the other light in the scene. As you rotate the filter on the lens, look through the viewfinder and see how your scene changes. Reflections on the surface of leaves come and go, a pond or lake can appear darker (greener or bluer) as you remove the reflections from the sky, the sparkle of snow can be eliminated or enhanced, and the blueness of the sky can be punched up, or taken down. You can both add to or reduce the contrast of a photo depending on how you orient the polarizer to the lens.

The one caveat to using polarizers is that they reduce the amount of light that reaches the camera. Your camera will take this into account and compensate accordingly with longer exposure times, but this may mean that in certain low-light cases you might not have enough light to hand-hold the camera during exposure. For this reason, these filters are best used in bright midday sun. The effects are more dramatic in bright light, though I do often use a polarizer with my camera mounted on a tripod when doing night photography to compensate for light reflecting off of the street in city scenes. As you gain experience, you will also find that a polarizer can be great for shots on a rainy day, under overcast skies, and in other atmospheric conditions that diffuse the natural light your eye sees.

In this photo, I used a split ND filter to balance the sun's brightness with the darker foreground.

Split Neutral Density Filters

Many of those spectacular scenic pictures you see in postcards or in photography books were probably taken using a split neutral density filter. Often abbreviated to "split ND," this filter has a neutral tonality (i.e., it does not add color cast to the scene) that gradually lightens from one side of the filter glass to the other. This makes it easier to capture scenes that include significantly brighter and darker elements. A common example is a bright sunset with a shadowy foreground. The photo above illustrates this perfectly: the shrubs in the foreground would never have come out if I hadn't used the darker part of the split ND filter to deepen the bright light of the sunrise and allow for a more balanced image.

Split NDs come in square or circular formats, and also vary in their density (i.e., how much light they filter out). In my experience, the circular split ND filters are virtually useless because the "split" is always in the middle of the filter, and you can't move it up or down, which is often where I find I need to compensate for difference in light. Split ND filters are rated in terms of the number of stops of light they filter out. I happen to own a 2-stop and a 3-stop split ND filter to accommodate everything from a mild sunrise (where I might only use just the 2-stop filter), to a more dramatic scene where I would sandwich them together to block 5-stops of light.

Graduated filters like the split ND don't have to be color-neutral. You can get colors as well. When choosing colored filters in a graduated format, understand that slight colors have dramatic effects on the final image. A graduated sunset filter, for example, can assist in reproducing the original colors of the sky that you see that could not otherwise be captured by your digital sensor because the light range exceeds the capabilities of the media. Lastly, it should be noted that some pictures just don't take well to split NDs or other graduated filters simply because the complexity of the colors lack a clear delineated line between bright areas and shadows.

Camera Bags and Tripods

Camera bags and tripods are two of the most important purchases you will make. Unfortunately, many people rush to nab up the first or cheapest thing they see and end up with an item that doesn't suit them as well as they need it to. With this in mind, I have outlined two key points that will help you on your way to purchasing quality items that won't soon need to be replaced:

1. Lower-priced items are usually vastly inferior to higher-priced items. Since the observable aesthetic differences are so minimal, it's hard to believe that the higher cost items are actually worth the money, so a lot of people end up buying the less-expensive versions. You may think you're saving yourself money, but you will likely find that you become increasingly frustrated with the quality and usability of your cheaper purchase and end up laying out the big bucks for the quality items in the end. And this means you've wasted money by buying the cheap item.

2. Realize that your need will evolve. Emerging photographers think they need to "grow into" needing higher-quality, more accommodating equipment and accessories, so they buy low first and upgrade later. As you discover the shortcomings of your less-expensive choices, you'll eventually replace them with the next higher quality choice in the line-up. This is how an accumulated cache of barely-used products begins. Now, I'm not suggesting you start out with the very top-of-the-line product offerings. Quite to the contrary, the problem is that not everyone is the same size, has the same strength, shoots the same subjects, or carries the same equipment. Darn. And to make matters worse, each season, manufacturers come out with new lines of products to replace last season's line-up in anticipation of the next round of remorseful buyers. So, the best advice I can offer is to choose wisely from the start and anticipate your growth as a photographer. Buy something of a bit higher quality than you think you need and you won't outgrow its usefulness as quickly. You may only have one lens now, but go ahead and figure that you might buy another one or two in the next year or so and be sure the camera bag you purchase can accommodate them. Maybe you don't have much experience shooting with a tripod, but go ahead and assume that you'll find using it invaluable and buy one that will stand up to a lot of wear and tear.

Camera Bags

There are two essential camera bag functions you need to consider when purchasing; one is transport and the other is active shooting. Bearing that in mind, you may need two camera bags if you have significant equipment that you wish to bring on your trip but don't necessarily want to haul around each and every item on a day of shooting. Two basic camera bag designs will serve your needs: backpacks and hip/sling bags. Each is invaluable in various situations, but what you really need to look for are those that have the durability and ruggedness to carry potentially large and/or heavy equipment, which you will undoubtedly acquire more of as you advance in skill and experience. By consequence, you may feel like you're buying a more expensive bag than you need when you're starting off, but trust me when I say that it won't take long for you to discover its usefulness. That said, it's also possible to overdo it and buy far more bag than you need, so we need to examine this further.

Let's start off by talking about transporting your photography gear. You're going on a plane, and you need to get your equipment safely and securely from one country to the next... or from California to Maine. It's true that you need a good camera bag to transport your equipment, but it's also easy to over-purchase by getting a bag based on it being able to fit everything you own inside. Before making that mistake, sit down with your photo gear and determine what you actually want or need to have with you on your trip.

If you have an appreciable amount of equipment, you will likely need one bag for transport and another bag that's easier to tote around on a day of shooting. If this is your situation, the most important bag feature to look for is its ability to protect your gear from harm. Worry less about being able to get to your equipment (as this type of bag is not designed for shooting on the go) and more about protecting it from being banged around in the overhead bin in the plane, train, or in the trunk of a taxi.

Having a bag that offers quick and easy access to your equipment becomes essential, on the other hand, when it comes to active shooting. And here, the bag's degree of protection is a comparatively less-important objective. When looking for a camera bag of this nature, again, it is easy to over-purchase if you're determined to get something with tons of protection that you simply don't need. So, put yourself in a real-life shooting scenario where your aim isn't to pack your equipment, it's to get at it quickly and easily. If you can't use the bag easily and effectively in real-life situations, it's not the bag for you.

On a final note, however, if you don't have much equipment and decide that you need a bag that is both small enough to carry on a day of shooting and padded enough to protect your equipment in an overhead bin, go ahead and spend the extra money to make sure that your bag is as functional as you need it to be. And hey, in this case, you aren't already shelling out for that extra transport-only camera bag, so spend a little more to be sure that the bag you do buy is exactly what you need. Now, let's examine the different bag types.

The Backpack: Backpacks come in various sizes from the smallest "intro" bags to the over-sized trekking bags that can hold a small camera store. Photo backpacks are perfect for transporting equipment safely. If you are purchasing a photo backpack specifically for transport, a mid-sized bag with lots of good padding should be perfect for your needs. On the other hand, if you have very little photo equipment, you may be able to get away with having just one dual purpose camera bag by purchasing a smaller sized backpack that works well for transport and also makes for a great active shooting bag. The smallest sized photo backpacks usually carry one camera body and two or three lenses. Keep in mind that if you want to transport other items such as a laptop, a card reader, an external hard drive, a flash, filters, etc., you may want to go back and reconsider getting a separate transport bag and active shooting bag.

One other thing to think about if you're considering using a small backpack as your active shooting bag is that backpacks are a bit awkward when it comes to accessing your equipment. Active shooting often requires access to lenses and such while standing up and/or walking, and having stuff on your back where you can't get at it makes things hard. Sure, you can set a backpack on the ground next to you, but that presents a problem in some situations, like shooting in the street, or being in conditions where the ground is muddy, dirty, or otherwise covered with debris.

If you're going to get a backpack used for both active shooting and transport, a design characteristic you'll want to avoid is the front-loading model, which is where you open the backpack on its front side rather than through the top like a typical backpack. In other words, to get access to equipment you have to lay the backpack on its back and open up the front. The intent is to allow access to as much stuff as possible at one time. However, the problem is that the back side of the pack is what ends up on the ground, which might be dirty or unstable as we just discussed. It's the same side of the pack that rests on your back while you're carrying it, so whatever sticks to it from the ground will now be rubbing against your back as you walk. This isn't a problem for studio photographers who can leave their backpacks on a clean floor, but for travel photography, this design doesn't work so well. Top-loading backpacks are best for combination transport/shooting bags, especially those with reinforced bottoms that can sit firmly on the ground. Unfortunately, since most people buy backpacks for transport only, few camera bag makers use this top-loading design anymore. You may have to do some searching if you have your heart set on a backpack that's also functional for shooting.

The Hip/Sling Bag: The hip bag (also called a sling bag) design compensates perfectly for the main drawback of the backpack. This style bag slings over the shoulder and hangs by your side. (It can also hang in front of or behind you depending on how you feel most comfortable moving with it.) They are almost all universally top-loading. Hip bags have a large main compartment that allows for easy access to your equipment, clearly designed for the active shooter. You can use these bags for transport, but its placement around your body may make it awkward to carry other things at the same time. Therefore, it may be worthwhile to pack your hip bag with your luggage and haul your equipment in a backpack. Now are you beginning to see why you may need two different camera bags?

Tripods and Camera Support

Tripods are a necessary evil of travel photography. When you already feel like you're carrying too much, adding such a major bulky object isn't fun. For this reason, many traveling beginners to photography simply bypass the tripod completely, which I absolutely do not recommend.

First, let me get this out of the way: Don't bother with monopods. They're great for bird watching, but are sub par when it comes to providing steady camera support during long exposures. You need to have a bona fide tripod. The best tripods cost far more than you think they should because they are made of carbon fiber. This material has the strength and durability to not jiggle when there's a light wind or when footsteps fall nearby. Plus, they are much lighter than their cheaply made counterparts, which allows for much easier transport. To me, these key points make the higher price worth paying.

The next important thing to look at when choosing a tripod is the length of time it takes you to set it up and take it down. How long does it take to extend the legs, lock them into place, make minor adjustments, and then pack up after your shot? Dealing with tripod setup and teardown can become quite an annoyance, so you want to be sure to purchase a tripod that takes a minimal amount of time. The thing to look for is a turnkey or latch mechanism that locks the tripod legs in place. There are other locking mechanisms, but these two are the least cumbersome and provide the most reliable support for the tripod's leg extensions.

Tripod Heads: If you purchase a high-quality tripod, you will likely have to buy the tripod head separately. The tripod head is what secures your camera to the tripod. It'll be another chunk of change, but it's a one-time expense that is well-worth the added investment to get exactly the kind of head

If you're going to be using your tripod in a cold climate, consider buying styrofoam pipe covering, found at any hardware store. Tape a small piece to the parts of the tripod legs where you carry it and, gloves or not, your hands will be protected from the cold metallic chill.

that you want. There are two basic designs: the three-way pan head, and the ball head. The pan head design uses two different levers, each moving the camera in a different direction. The idea is that you can pan left or right without affecting the camera's up or down positioning, and vice versa. By contrast, the ball head lets you move the camera in any direction just by pointing it and using a tightening mechanism, which can be a button, trigger, knob, or lever. Ball heads are lighter, easier, less bulky, and (you guessed it) more expensive. The smaller and lighter they get, the costlier they get. The major consideration here is weight, just like with the tripod itself. So, again, carbon fiber is the best bet.

I shot this image with a small table-top tripod. These tripods are very lightweight due to their small size, and are therefore very practical for the active shooter to carry along. Keep in mind, however, that the legs of these small tripods do not extend very far so they will not take the place of a full-sized tripod.

Other Useful Accessories

With all this camera equipment, you'd think your bag must be full already. Well, we're almost there. There are a few more things you might want to pack, and fortunately, they're all small.

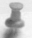

If your camera has a video function and you plan to use it, consider doubling the amount of memory you would otherwise buy. I have seen many people become frustrated when they realize that the digital video they've taken has eaten up all the space on their memory card.

Memory Cards

What's unique about travel photography as opposed to every-day shooting is that you tend to take many more photos over the course of a day, and you may not have the chance to download your images to an external storage device right away. Therefore, buying a high-capacity memory card for your camera is advisable. What size you should get is some-what based on how many megapixels your camera uses to make a capture; the higher the megapixel resolution you're shooting at, the less pictures will fit on any given memory card. Some digital cameras will allow you to select a lower resolution setting if you need to fit more pictures on the card you've got, but ideally you want to make the most of the res-olution that you paid for when you bought your camera. So, make sure that you have a memory card with plenty of wig-gle room so you don't find yourself compromising by shoot-ing your once-in-a-lifetime vacation photos at a less than ideal resolution. My advice is to get at least a 2 G (two giga-byte) card. This should certainly last a single day for prolific photographers with eight-megapixel cameras, or maybe even an entire trip for someone with a five- or six-megapixel cam-era if you only take 20 to 30 pictures a day. If you really want to be on the safe side, you may want to buy two sepa-rate 2 G cards, or one 4 G card and an additional 1 G card for backup incase you fill up the first card. Stop in to your local camera store and talk with a salesperson about your shooting habits and your camera's resolution. They will likely have a good recommendation as to how much memory you should take on your trip.

How many images your memory card can hold at a specific resolution depends on what ISO sensitivity you are shooting at. Images captured using higher ISO settings will eat up more memory.

External Storage Devices

If you know that you will be taking a lot of photos and don't want to go overboard purchasing tons of memory, an external storage device can be used to download your photos at the end of the day so you can clear your memory card for the next day's use. I have an external hard drive for this purpose, but there are many other options available. People are beginning to use their MP3 players as storage devices, and Apple's video-based iPod is also good choice, especially for those who already use the device for other tasks. Obviously, if you've brought your laptop along with you, you can just plug in a card reader and download your images that way, too.

Cable Release

If you ever do long exposures, you need to have a cable release. Each camera manufacturer has their own proprietary kind, so refer to the manufacturer's website or your instruction book to place an order. Be sure to pick one up, though, if you have any desire to shoot exposures that are longer than the maximum exposure time your camera otherwise allows (often 30 seconds).

Miscellaneous Stuff

Here are some other items that I have found to be necessities when traveling:

- √ A tiny flashlight
- √ A padded pouch for your filters
- √ A hot-shoe mounted bubble level (used with the tripod to make sure the camera is level)
- √ Snacks
- √ Pens and paper
- √ Your camera manual (Oh yes—bring that manual)

All of these little things should fit easily in whatever bag you're using for active shooting. And one last word of advice about packing: Determine the places where things go and leave them there, even when you're at home. Never remove items from your pack unless you're using them. There are so many things to remember that you simply can't expect to think of them every time and pack them up. You will invariably forget to pack something, especially those important but rarely used items, and you'll curse yourself for having forgotten. So, the best thing to do is populate your camera bag once, never take things out unless you're using them, and replace them back in their designated spot when you're done. You'll also begin to get used to things being in the same place every time and quickly go right to the item you're looking for without wasting time rummaging through your gear. Traveling with your camera will be even more fun if you take the time to actively eliminate the stress caused by disorganization. If you have your equipment in a state of readiness that allows you to leave on a moment's notice and shoot most any kind of situation, you'll never suffer from that frustration that plagues even the pros.

people
and places

The word "snapshot" was coined in the 1800s by a man who had just returned from a bird hunting trip. He proclaimed that his poor yield was due to his shots being fired quickly, without deliberation. "They were snap-shots," he declared dryly. The term never stuck in the hunting world, but it was later applied to photography and hasn't changed its meaning since. Like the hunter who coined the phrase didn't bring back many birds, photo "snap-shots" will not yield many good photographs either.

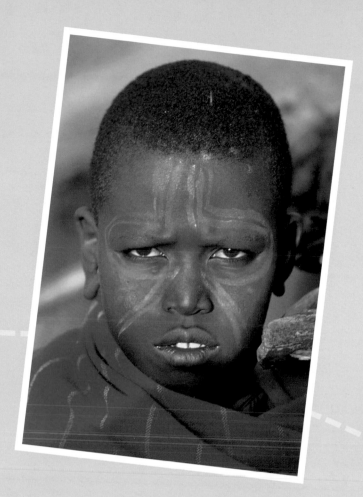

Photographing People and Developing Intent

Good pictures of people are those that exhibit something about the person that touches us somehow. Whether you're shooting pictures of native peoples from foreign countries or your sister feeding birds in Venice, you'll find that the most challenging part is not technique so much as understanding your subject and portraying that understanding in your photo. This is where intent comes into play.

When you see a great "candid moment" picture of someone, it's easy to assume that the photographer just got lucky with being in the right place at the right time. And certainly, it does happen that way sometimes, but more often than not, a great people picture is the result of practice. "Sure," you might be thinking, "if you shoot a zillion shots, one of them is bound to be good." And you would be right. As I've mentioned before, even the pros rarely get the shot they want with just one click of the shutter button. It isn't until you've taken those zillions of shots of your subject that your yield of "good" pictures starts to improve.

Exploring a subject from all sorts of different angles rather than just pointing, shooting, and moving on will help you realize that getting a great shot requires getting closer to your subject, often both figuratively and literally. The first step to developing photographic intent is getting to know and understand your subject matter. Once you achieve this understanding, you can move on to the second important step of developing intent: Examine what techniques have worked best for you with certain subjects and refine your shooting to achieve as many "keeper" shots as possible. With these two ideas in mind as you shoot, you will be more conscious and thoughtful of how your images portray your subject.

Think about a particularly moving photo that you've seen of a person in a magazine (or even in a photo album), and try to find your own way to capture a side of your subject that evokes a certain mood or emotion when you look at the image. Your digital camera is a great tool for exploring human nature. And the best part is that you can take as many shots as you need to without worrying about wasting film; just review and delete any shots that obviously failed, but remember that the LCD monitor is a poor representation of the actual image, so don't be too quick to erase a shot that might be a good one.

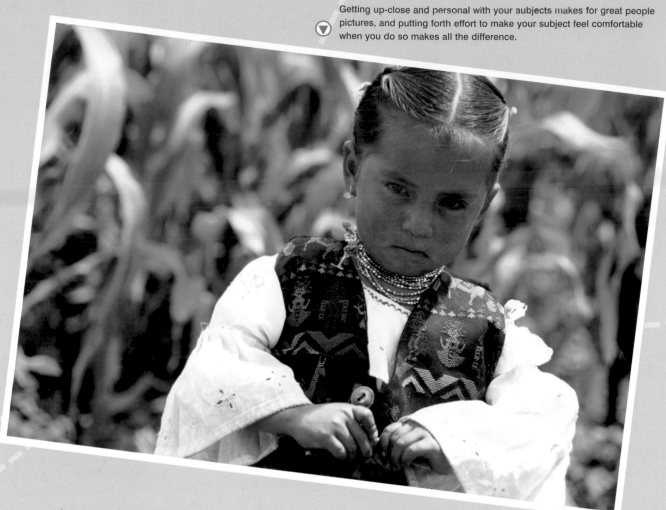

Getting up-close and personal with your subjects makes for great people pictures, and putting forth effort to make your subject feel comfortable when you do so makes all the difference.

Get out of Tourist Mode

When traveling in unfamiliar environments, you may not necessarily understand how you will be perceived by the people you're trying to photograph. Some of you may barge boldly forward, taking pictures as if your subjects were animals in a zoo; some of you others may be reluctant to raise the camera to your eye at all, concerned that you are invading the subjects' space or violating their privacy. Will they take offense? Do the people of that culture believe that having their photo taken will steal their spirits? Should you ask for permission first? Should you pay them for taking their picture? These are all valid questions to ask yourself, whether you find that you are the "go-getter" type of photographer or a more hesitant one.

When it comes to getting good pictures of people, the primary problem people have is being in a tourist frame of mind. As long as you consider yourself an outsider, you'll be treated as one, and that distance between you and your subjects will be discernible in your photos. To remedy this, you need to establish a rapport with the people around you. Be interested in them. Communicate with them. You want a photo that reflects

who they are, how they feel, and what their life is like in their own environment. If you join them in their space, you won't feel like you're invading it (and they will be less likely to think that you are either).

Now you might be thinking, "I'm in a country where I don't speak the language. How can I communicate with the people I see?" Communication is far more than just words. First off, a smile is a smile no matter where you are. Secondly, body language, gestures, and symbols can communicate lots of information without the use of words. Just make an effort to be friendly and respectful, and more often than not, people will respond more positively to your presence.

When on a photo workshop in Cuba, I was working with a student who wanted to be a travel photographer. Her portfolio had great scenic pictures, but she had no people pictures. She said she just never really got good pictures of people, so she didn't show them. When we were out shooting, I could see why; she wouldn't approach anyone, or even bother to take a grab shot in open squares or forums (a technique that travel

photographers and photo-journalists often employ). When asked why she didn't take pictures of people, she gave the old stock answers: "I don't want to bother them. They don't want their picture taken," or "They wouldn't let me."

Meanwhile, I wasn't having any of those problems. In fact, Cuba has got to be one of the easiest place in the world to photograph people; most are friendly and very photogenic. I've even had people demand I take their picture as they saw me walking by with my camera. As my student and I were talking, a girl happened to walk by and grab her attention. "I really wanted to get a picture of her," she said as we both watched the girl walk by. I said, "Well, if you're uncomfortable shooting from a distance, just go up to her and ask." The student hemmed and hawed, partially because the language barrier made it intimidating for her to attempt contact. With a little nudging, I got her to approach the girl, but she quickly backed off and said, "See, she doesn't want her picture taken."

Herein lies the lesson of this story: The more uncomfortable you are with your subject, the more uncomfortable they are going to be with you. It was clear to me that the student simply didn't feel comfortable approaching people, so it was no wonder that she didn't have many good people pictures. Confidence, respect, and friendliness are the three simple keys to approaching a stranger and snapping out of "tourist mode." To demonstrate this to my student, I proceeded to walk right up to the Cuban girl she had avoided and say, "Hola!" (a common Spanish greeting). The girl smiled, and then I made a few gestures about liking her t-shirt, to which she gave me a friendly nod. Then I pointed to her shirt and to my camera and asked, "Photo?" She smiled and said, "Sí," I snapped the picture, thanked her, and we parted ways.

Except for in cases of a subtle grab shot, if you want to photograph a stranger, you've got to take that first step and open a line of communication with them. Sure, it may mean that both you and your subject are stepping a bit outside of your respective comfort zones, but you just might get a phenomenal photo out of the deal. And besides, what better way to get a true sense of your vacation locale than to communicate with the people that call it home? As with many of the other photographic techniques and concepts we've discussed, a little effort goes a long way.

Confidence, Respect, and Friendliness

First and foremost, don't be afraid. Start with friendly eye contact and a smile, and downplay your photographic intentions; swing your camera around your back, and approach people just as a person, not as a photographer. Talk to them, even if you don't know the language. A word or two to greet them and an attempt to sue gestures to communicate often gets you 90% of the way there. Once you establish yourself as comfortable in their environment, they will be comfortable with you. If at this point, you want to take some pictures, you'll have a much more receptive audience. And if not, you've still shared a unique experience with them that neither of you would've had otherwise.

Children are often the best subjects, since they're fun, cute, and lively. One of the most common hurdles you need to clear, though, is their apprehension to you (and often to strangers in general). Your camera will only intensify that fear if you barge right up with it in their faces. But before you start trying to set these young potential subjects at ease, if there are parents present, the respectful thing to do is to establish a rapport with them first. (How would you feel if some stranger came over and started taking pictures of your child without your permission?) Once mom and dad accept your presence, the kids will likely be more comfortable with you, too.

For the most apprehensive kids, I've found the easiest thing to do is let them look through the camera. They'll laugh and scream and compete with each other to get a good look or two. You can even let them take pictures of each other, although this will surely result in a lot of time expensed. (With digital cameras, be prepared to preview a lot of photos.) Before you know it, they all want to be in the picture. (See page 81 for more about photographing children.)

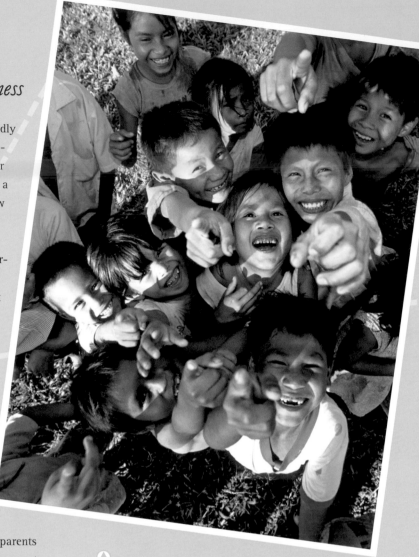

Children love to play, so make taking their picture fun.

Digital cameras allow you to share the photos you've taken with your subjects, which is a great way to get them excited about being in a picture.

Improving Your Technique

Once you've gotten comfortable with the process of getting to know your subjects, the next step is to develop an eye for what kind of pictures you like. You can think of this step as having two sides to it: an artistic side and a technical side. In the end, whether a picture is "good" or "bad" is a matter of personal taste, but what I can do is provide you with a basic checklist for improving your technique:

√ Proper use of flash: A flash can work for you or against you. It's important to understand these basic facts about flash:

• A Flash is largely ineffective beyond 10 feet.

• Avoid using flash as your main light source. People will be overexposed, and you'll rarely see the background.

• Use fill flash in midday light to brighten dark shadows.

• For night photography, turn off your flash and increase your ISO setting and/or your shutter speed.

• Using flash with a slower shutter speed (1/8 to 1/10 second) is a good way to both freeze action to capture the faces while also allowing the motion blur from the longer exposure to emphasize the movement.

√ Experiment with different angles and focal lengths: Zooming up close is great, but other vantage points can also yield exciting effects that you might not have anticipated.

I captured this shot using a wide focal length and shooting upward from below my subject.

△ Motion blur doesn't have to be a mistake. It can be used creatively, especially in a scene such as this that aims to depict the motion of the subjects.

△ Avoiding flash indoors yields a more naturally balanced photo, but you will likely need to increase your ISO setting.

√ **Show your pictures to your subject:** Nothing embraces people more than their seeing themselves on your camera's preview screen. Almost instantly, people's objections to having their pictures taken are replaced by enthusiasm and eagerness.

√ **Choose your background:** An "inventory picture" is one you take to prove you were there. A "good picture" is one where the background compliments your subject with a more accurate sense of place. Pay attention to each scene element that appears in your viewfinder and consciously place it within the frame.

√ **Capture people engaged in activity:** A photo of someone engaged in activity can tell the viewer a lot about who they are or what they do, making your image more interesting. When shooting portraits of artists, craftsman, or trade workers, for example, incorporate their craft into the picture.

△ The calligrapher was my main subject, but I used the work in front of him and the window behind him to extend the scene visually.

It's nice when your friends look at the camera and pose, but when people are engaged in an activity, photos become more interesting.

Photographing Children

Photographing children is a great way to get a ton of good, fun, people pictures. However, it can be a bit of a challenge, especially if you don't speak the language. Children in heavily populated tourist spots often become jaded to the rudeness of tourists who lunge at them with their cameras. When faced with this situation, the easiest way to introduce the idea of taking pictures is to let them look through the camera first. In fact, I let them take pictures of me before I photograph them.

Most people shoot while standing in an upright position, but a fun technique to try when photographing children is to get at eye level with them. This shows the world more through their perspective rather than yours, and it also means that you won't be looking down at them, so the background rather than the ground they're standing on will be part of the image.

Silhouettes

One way to make a person really stand out, even when they take up a very small part of the scene, is to photograph them in silhouette. When a dark human shape punctuates through a bright scene, it not only draws attention to the vastness of the landscape, but it also creates a sense of the person's relationship to it. Silhouettes are only effective when the subject "pops out" from its background, which should be significantly brighter than what you may think. Remember, the human eye isn't limited in the same ways a camera is, so this may take some practice. Here are a few tips to start you on your way:

√ Make sure that the background isn't too dim to begin with, such as a forest or the darker side of a mountain. Silhouettes against already dark background don't work very well.

√ It is also important that the subject's outline doesn't overlap with other dark objects or dark parts of the background.

√ If you are combining subjects, like groups of people, then some degree of overlap may be inevitable, but more separation between each person will look better.

√ You can also photograph structures in silhouette, such as shooting through windows or doorways or from behind a tree. Here, the silhouetted structure can provide a main frame, or a series of frames (like multi-paned windows) for your background subject matter.

When it comes to shooting silhouettes against a brighter background, be sure that your camera is metering on the background light, not on the silhouetted subject. A quick review of your image on your LCD monitor should reveal whether or not you got the shot you wanted.

A couple silhouetted creates a sense of intimacy.

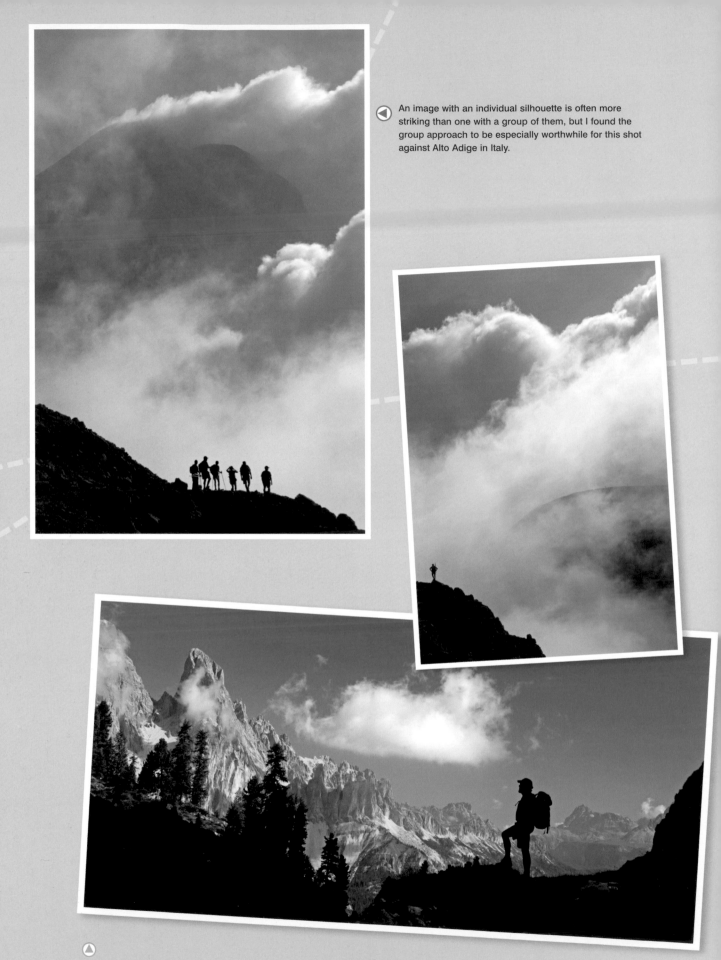

An image with an individual silhouette is often more striking than one with a group of them, but I found the group approach to be especially worthwhile for this shot against Alto Adige in Italy.

Another aspect to consider is the "power of one." A single individual tends to have a more dramatic effect than a group. Although both have their strong points, the visual impact of a solitary figure is worth spending extra effort to get.

The Power of Juxtaposition

The juxtaposition of the subject to the environment can be funny, intruiging, profound, or disturbing. When my funny bone itches, I try to place people next to things that are either completely opposite in nature (or at least, unexpected).To me, the juxtaposition of these two photographers is funny. Since everyone's perception of humor is unique, simply look for scenes with two or more subjects that look mismatched or humorous together to your eye.

Color

When a single, bright color punctuates through muted tones, it draws attention. Making color the theme in your photograph can be challenging, however, because we're so used to seeing it that it is easily overlooked. A set of vibrantly dyed yarns exploit color well, for example, but even if you notice the bright tones, seeing them all set against one another doesn't make them stand out as unusual or unique. So, what might a good example of using color as your main subject be? How about the overwhelming blue of the sky at dusk amidst a foreground of shadowy figures, or a single bright piece of clothing hanging from a clothesline in an otherwise gray, industrial, urban scene. When looking for color, you should also refer to the sections on silhouette (pages 82-84) and juxtaposition (page 85); if the color "pops out," it's interesting. If it's next to something that opposed or compliments it, it can be funny or moving. Use the suggestions in this chapter together or apart and you will soon find that you have multiplied your creative possibilities exponentially.

Black and White

Color is a very powerful tool for creating a striking image, but black-and-white photos can be just as striking—sometimes even more so. With digital cameras, any photo can be quickly converted to black and white with a simple click of the mouse using any image-processing software or photo-printing site. Some cameras even offer black-and-white or sepia shooting modes so that you can capture your image that way in-camera.

Shooting from Different Perspectives

Tired of the same old portraits? The quickest way to get out of a photo rut is by changing your perspective. Here are some suggestions for spicing up your photos:

• Get down on the ground and shoot at the lowest point you can. You'll be surprised at how the world opens up.

• Shoot from a higher vantage point. Reach up high, or better yet, climb up on some nearby sturdy object to get a new perspective.

• Use unconventional focal lengths for a given scene, such as using a telephoto focal length in a crowd or a super-wide angle for a portrait.

• Frame your subject. Find a nearby wall or pole or tree and use it to create a full or partial frame around your main subject. Interesting images often result.

For some of these angle and perspective experiments, you might be wondering how you'll see through the viewfinder when you're holding the camera high above or down below your subject. The answer is, don't worry about it. The great thing about digital cameras is that you can review your photos after attempting one of these suggestions and simply erase the ones that don't come out.

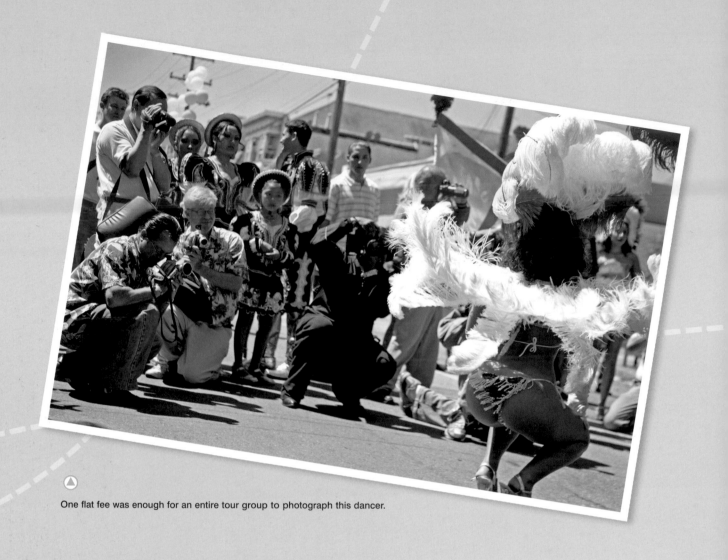

One flat fee was enough for an entire tour group to photograph this dancer.

Paying for Portraits

On occasion, you may seek to take someone's photo and find that they demand that you pay them for taking their picture. In my experience, this usually happens in poverty stricken areas. When money is scarce, any means of income is sought, and tourism is often the best and easiest way for locals to make a little money. Should you pay to take a picture? And if so, under what conditions? It's not always easy (or possible) to discern when it's appropriate.

If you're going to pay to photograph someone, make the most of it. Organize a formal shoot, bring in other photographers, set up the scene, use props, pose your subjects, and most importantly, shoot a lot of pictures. It's an excellent opportunity for subjects to express themselves. This may also be your only opportunity to get a really close and personal portrait of someone that would otherwise not give it to you.

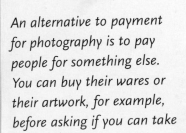

Paying for a photograph can enable you to get more up-close and personal with your subject that you would be able to otherwise.

Some argue that we pay models to take their pictures all the time. Whether it's a celebrity supermodel making millions of dollars per year or a part-time college student that makes a few dollars posing for art classes or the local ski shop's brochure, it is part of Western culture to pay people for taking their picture. From that vantage point, payment for photos while traveling doesn't seem so outlandish a concept, particularly if it reduces any degree of exploitation between you and your subject. You can also get much more cooperation from people when you pay them. What's more, you can arrange a lot more situations, such as organized group shots and other sorts of things. So, payment does have its rewards at times.

An alternative to payment for photography is to pay people for something else. You can buy their wares or their artwork, for example, before asking if you can take their picture.

Photographing Places

Capturing the architecture and scenery of the places you travel to is just as important as getting great photos of people. In most cases, all you really need to do is apply the lessons we've covered on compositional techniques (see pages 19-25) with good exposure and you've got the basics for a good landscape photo right there. However, there are some other issues and techniques to be aware of.

Subject, Composition, and Light

When people come across an amazingly dramatic panoramic landscape, the first thing they try to do is capture the whole thing in one big, wide-angle shot. Unless you apply the rules of composition, however, you'll just end up with a bland scene that has no apparent focal point. Any eye-catching photograph must have an interesting subject, a well-composed frame, and good lighting.

Morning and Evening Light: You may have heard of "the magic light" of early morning and sunset, which is a quick and easy way to make most any scene exceptional. The trickiest part is getting your desired exposure. There is no single best method; whether you under- or over-expose a picture is purely a creative decision. Play with your shutter speed, aperture, and exposure compensation settings until you achieve the desired effect.

Landscapes don't have to be exclusively nature pictures. They can include people, structures, and everything in between. Incorporating subjects into a landscape shot provides a context, a sense of place, mood, theme, and other qualities. Experimentation often yields more pleasant surprises than you'd think.

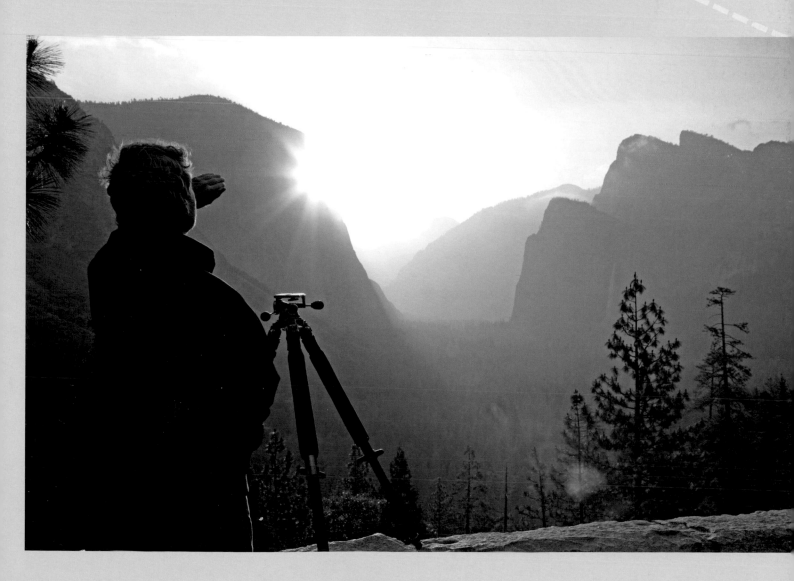

Sun Rays: Beams of light from the sun are exciting to see, but challenging to photograph. Often, what you see doesn't show up well in a photograph because the light is too bright or the contrast too subtle for the camera to capture in enough detail. You can sometimes compensate by composing the frame so the beams are set against a darker background.

Shooting Inside Places of Worship

Some people believe that you shouldn't take pictures inside of places of worship. This sentiment is most commonly seen in European countries, although it is certainly possible to run into it elsewhere. I have found that the more tourists there are, the more restrictive it is to shoot inside. Why? The most common reason is that it's believed to be disrespectful, but a close second is that flash can damage the paintings.

You will usually see a sign near the entrance dictating whether or not photography is allowed inside if it is a particularly popular tourist destination. Some signs will specify no flash photography, meaning that you can take as many pictures as you like as long as you don't use your flash. If no sign clearly directs you one way or the other, feel free to take the stance that photography must be allowed. However, as we discussed in the section about photographing people, be

respectful. People that are not there to worship risk interfering with the local few who are. As in a library, most people get the hint to keep their voices low and quiet, but having a lot of bursts of light can be really distracting to someone trying to communicate with the almighty of their choosing.

One great way to cause the least disturbance in these situations is to cut flash out altogether. Increase your ISO sensitivity setting and use slower shutter speeds. Having your tripod handy would serve you well here, as many churches, mosques, temples, and the like are dimly lit.

Back to the point though, most churches have no problem with your taking pictures. In any event, however, you should always respect any posted rules or instructions regarding photography, and don't try to skirt around them. You'll find that your photos will be far less interesting if you have to sneak them.

Summary

In conclusion, remember that the ultimate responsibility of the photographer is to extend respect, whether photographing a person, place or thing. If someone doesn't want his or her picture taken, don't do it. Recognize that photography is a cultural phenomenon, and is viewed differently by different people. Don't assume that your idea of what's appropriate or not is necessarily the same as those around you. Put a little effort in to understanding and respecting the places you go and the people you encounter there and you will soon learn where the boundaries lie. Expect people to be apprehensive, but don't let that discourage you from developing a rapport with them so you can take that winning picture.

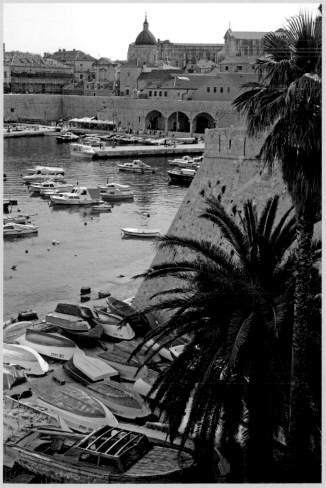

extended exposures

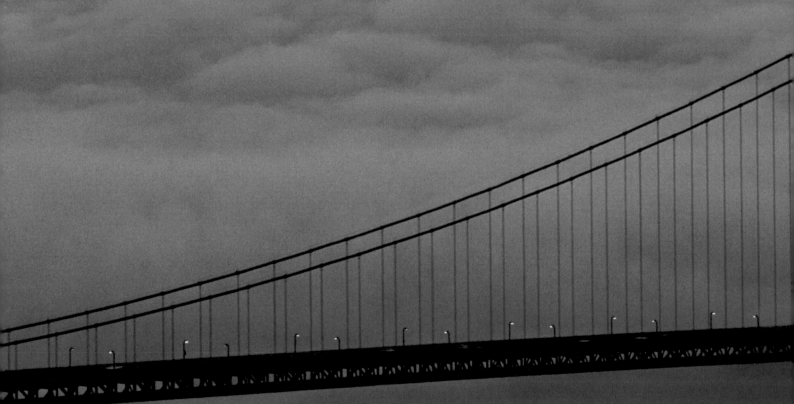

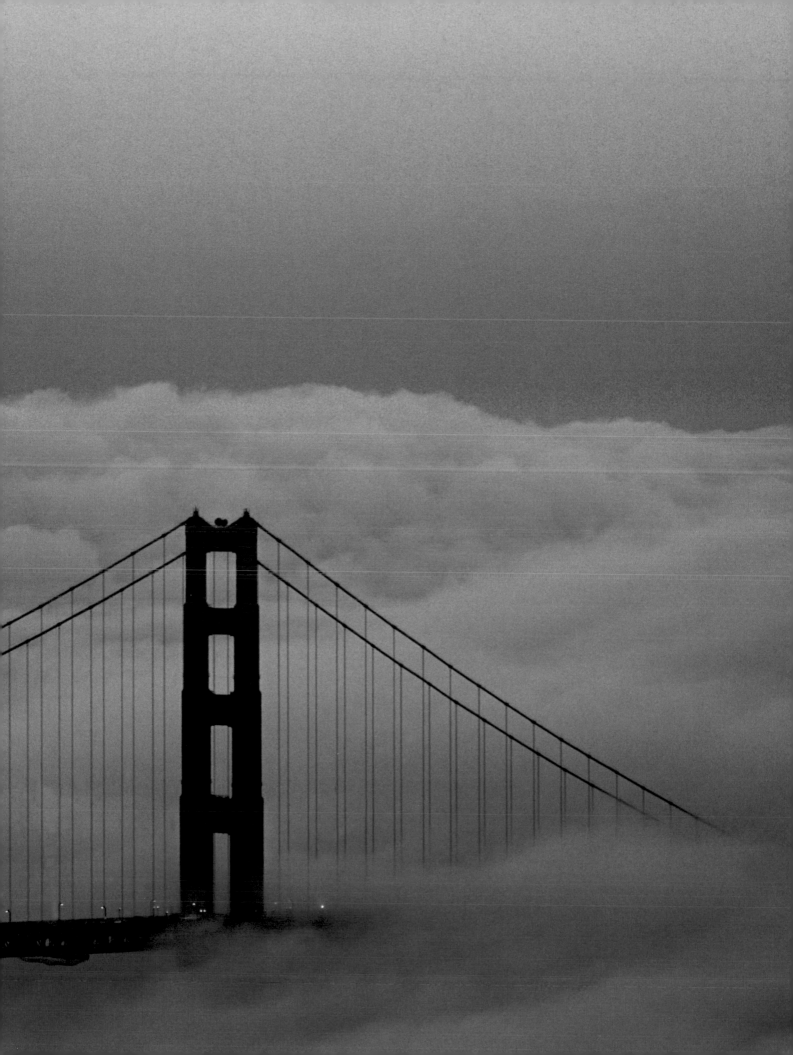

People often associate extended exposures (or the use of long shutter speeds) with night photography. This is certainly part of taking great travel photos but what is often overlooked are the amazing photos you can get at other times of the day with longer shutter speeds, ranging from 1/15 of a second up to many hours. These techniques aren't tricky and don't necessarily require sophisticated cameras and lenses (though anything longer than a short extended exposure is probably not possible if you are using a digital point-and-shoot camera). To make things even more understandable, I break these types of exposures down into three categories:

• Short extended exposures—These range from about 1/15 second to several seconds.

• Medium extended exposures—These exposures go from several seconds to about a minute.

• Long extended exposures—These exposures are indefinitely long, often going beyond the camera's shutter timing abilities and requiring the use of a remote release.

Short Extended Exposures

Shorter extended exposures are typically those where you want to intentionally capture the motion of an object or action. Shutter speeds around 1/15 of a second are common, but it could be more or less depending on the object, its speed, and other circumstances. That is, you may either be shooting from a moving object (such from inside a moving car), or you may be in a stationary position taking a picture of a moving object (like wildlife, people, waterfalls, etc.). Again, the intent is to intentionally blur the photo to illustrate the implicit direction and speed of the motion in the scene.

extended exposures

98

When shooting moving subjects in daylight, your camera's shutter speed tends to be pretty fast. To record motion effects you'll need slow down the shutter speed while maintaining the correct exposure. One way to do this is to use a very small aperture, also called "stopping down." With smaller apertures, less light reaches the sensor so the shutter speed must be longer to create the exposure.

Framing and Timing the Shot

Technically, this isn't rocket science, but the challenge is the composition. Because things are in motion, it's hard to frame your picture in quickly changing conditions. The other challenge is deciding when to release the shutter. Expect to shoot many pictures of the same thing, hoping for that one great shot. One hint about composition is to pay attention to the direction of motion, since that will be the theme of the picture. Straight lines, curved motion, forward, backward. It's all about leading the viewer's eye from a starting point to an endpoint. It may be subtly implied or very direct, but it's the motion itself that you want to convey.

To adjust your aperture while maintaining a correct exposure, use your camera's Aperture Priority function, often abbreviated to A or Av. To adjust your shutter speed while maintaining a correct exposure, use the Shutter Priority function, which may be abbreviated to S or Tv (time value).

When shooting from a stationary position, something else in the scene must not be moving or the effect is lost. Hence, it is necessary to keep the lens stable during the exposure to keep any fixed objects still. At a shutter speed of 1/8 second or so, one can, with enough practice, learn to be relatively still, but even then, it still requires repeated shooting. If you're on a train or in any not-so-steady situation, use a tripod or other camera support.

Moving clouds are also excellent subjects for extended exposures. For example, this photo of Mount Veronica, Peru, shows how clouds appear when they move over mountains. Shooting just about any night scene with moving clouds can produce interesting effects, but be careful not to expose for too long. Given enough time, the whites of the clouds will eventually pass by all the open spaces in the sky (even if it's never entirely overcast), losing the "swoosh" effect.

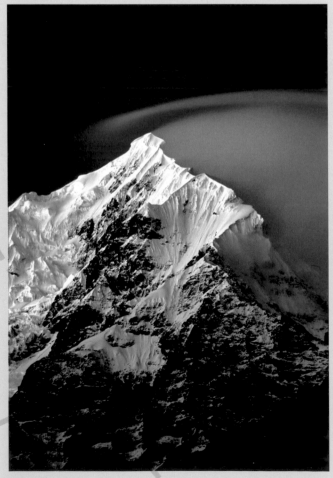

Medium Extended Exposures

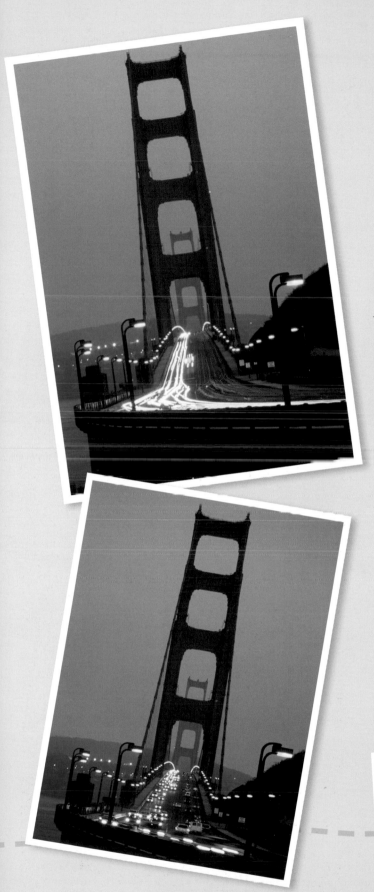

Medium length exposures are generally the most common type of long-exposure work. You'll definitely need a tripod or other camera support. Dusk, dawn, and many night scenes in cities with traffic are good subjects because there is often ambient light to fill in the shadows, which balances out the highlights. Traffic at night is one of my favorite subjects.

As the photos on this page illustrate, streaking lights from cars show a sense of motion, and are very appealing. The longer the exposure, the longer the streak of the car lights. There are many ways you can play with this effect. As you get more familiar with the process, experiment with the timing—when you start and stop the exposure has a great impact on the final result.

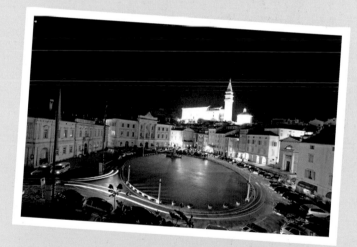

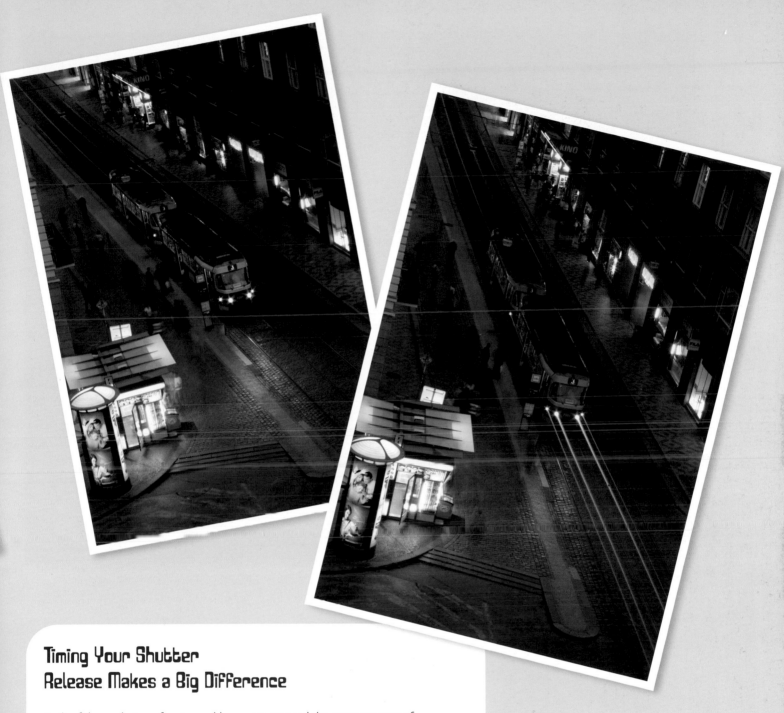

Timing Your Shutter
Release Makes a Big Difference

Both of these photos of a stopped bus were exposed the same amount of
time: 30 seconds. However, the headlights for the bus on right-hand image
appear to beam forward. This is because the bus was stationary for the first
25 seconds before it began to move in the last five seconds. The brightness
of the headlights was captured, but the bus' movement wasn't recorded
because it didn't emit (or reflect) enough light to affect the longer-term
imprint that had already registered. A shorter exposure might not have pro-
vided enough time to imprint the stationary bus, and would have allowed
the brief time it was moving to have a more pronounced effect. To success-
fully capture this effect, I had to use some trial and error. (It took about an
hour to experiment with this—much of the time involved waiting for anoth-
er bus to come by.)

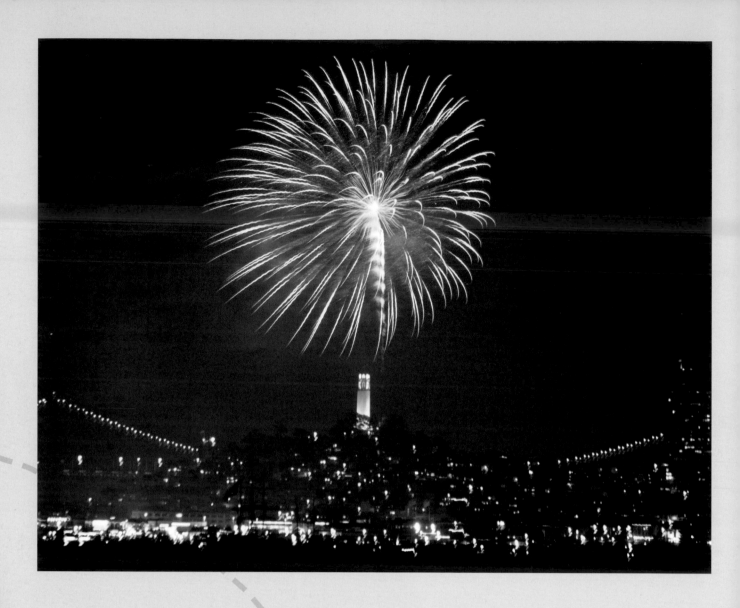

Fireworks

Fireworks seem to be everyone's favorite subject. While beautiful, they can be highly unpredictable, so again, prepare to shoot many frames and end up with more bad results than good ones. The main problem is figuring out what exposure to use. If it's too long, the fireworks themselves overexpose, and if it's too short, all you get is fireworks and no background, or context. The solution to this is shoot for the background—that is, expose as if it's a night shot—and try to time your shutter releases so that the firework's burst is at the beginning, or the end, of the exposure. You'll have to shoot at least one picture of the scene without any fireworks, just to gauge what the base-line exposure is. Once you have that, you can time the fireworks accordingly. (That is, attempt to have the burst of fireworks occur during the first or last 5 seconds of, say, a 30-second shot.) This way, the basic scene will come out right, and the light from the burst won't be overexposed. You want at least a second of it (and up to about five seconds) to get the "motion" of the sparks, or the photo probably won't be pleasing. Again, experiment till you get a look you like.

Clearly, the lottery game is determining when the operator is going to let off the next one, and generally, it is not worth shooting when he lets them off back to back (unless you like the abstract/artsy look). Except for those situations, I'll shoot every moment of an hour fireworks display and be lucky if I come up with five good shots. And if there's a strong wind—forget it. Conversely, the smoke can become a visual eyesore if there isn't enough air circulation to clear it out during the performance.

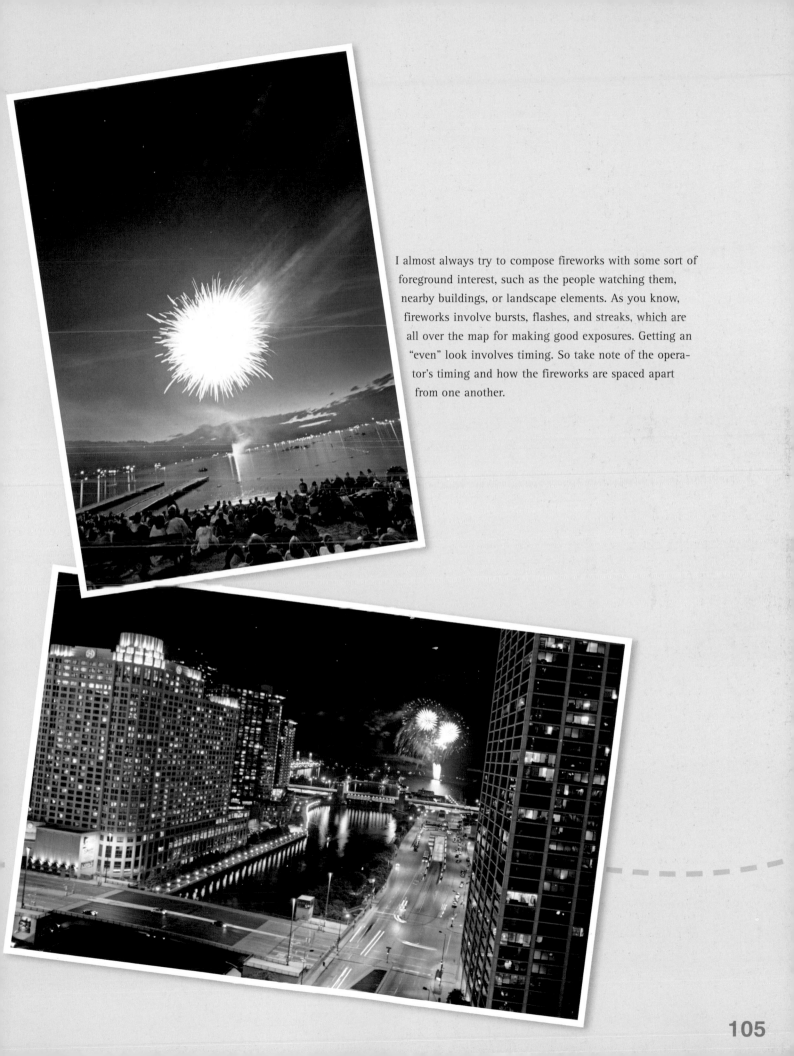

I almost always try to compose fireworks with some sort of foreground interest, such as the people watching them, nearby buildings, or landscape elements. As you know, fireworks involve bursts, flashes, and streaks, which are all over the map for making good exposures. Getting an "even" look involves timing. So take note of the operator's timing and how the fireworks are spaced apart from one another.

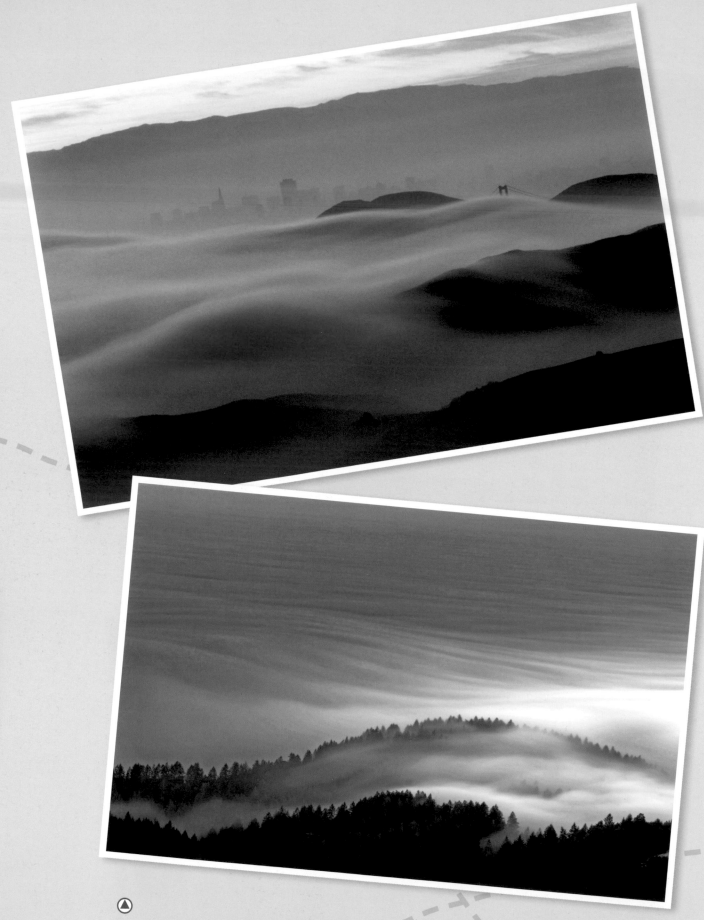

Fog is rarely motionless, so it is a great subject for extended exposures; its movement appears as "flowing cream" when low to the ground. (You tend not to get this effect if the fog is hovering.) This type of photo is best shot when you are at a significant distance from the fog.

Shooting During the Day

The challenge with long exposures during daytime is in reducing the ambient light enough to permit the extended exposure. Stopping down your aperture (as was done for the shorter category of extended exposures) won't be sufficient for these, because you need to block even more light. The solution is to use a neutral density (ND) filter (not to be confused with the split ND filter discussed earlier). These filters are neutral in color, and they serve no other purpose than the reduction of the total amount of light reaching the sensor. ND Filters come in many strengths—blocking from one stop of light up to 13 stops. Each stop doubles the time of your exposure because it blocks twice as much light as the previous stop.

◄ This photo was taken with a normal exposure.

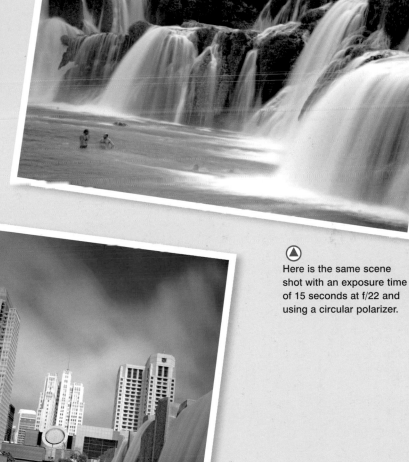

▲ Here is the same scene shot with an exposure time of 15 seconds at f/22 and using a circular polarizer.

Flowing water has a similar effect as fog and it's much easier to find. Whether a river or crashing waves, any type of liquid movement is a good candidate for longer exposures.

107

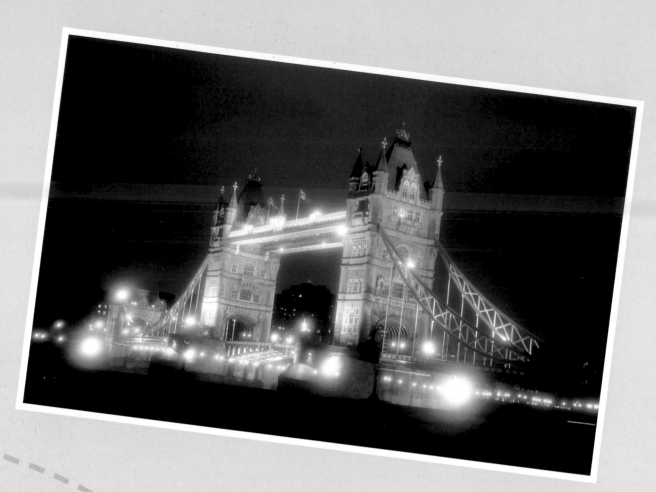

Long Extended Exposures

Long exposures are great for capturing cityscapes, star trails, moon lit valleys, and lightning. In this case, we are concerned with pictures made at night, with exposure times that last from several minutes to many hours. (If you set your ISO rating high enough, you can also get good night pictures with only a few seconds of exposure. These may look nice in small format, but digital noise will probably be obvious if you make large prints. In all the cases discussed here, a tripod and locking cable release are essential; you won't be able to keep your finger on the shutter release the whole time without moving the camera.

Beware of digital noise in long exposure photography. Cameras vary widely on the frequency of noise they produce, so you should experiment to determine your camera's capabilities. (See page for a discussion on ISO and digital noise.) Always choose the lowest ISO setting on your camera for long exposures to minimize noise. Noise is produced by the

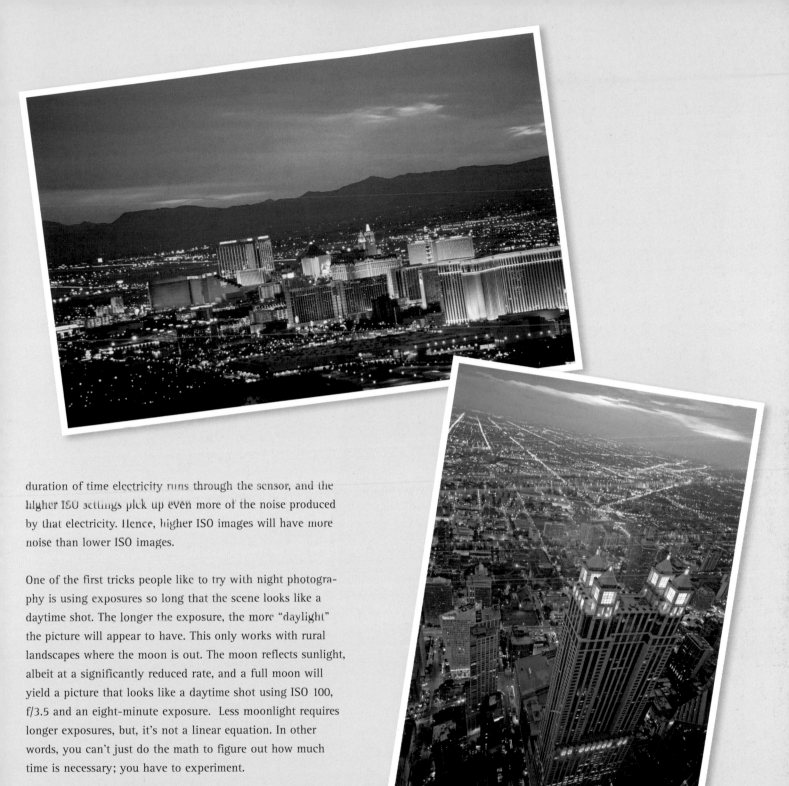

duration of time electricity runs through the sensor, and the higher ISO settings pick up even more of the noise produced by that electricity. Hence, higher ISO images will have more noise than lower ISO images.

One of the first tricks people like to try with night photography is using exposures so long that the scene looks like a daytime shot. The longer the exposure, the more "daylight" the picture will appear to have. This only works with rural landscapes where the moon is out. The moon reflects sunlight, albeit at a significantly reduced rate, and a full moon will yield a picture that looks like a daytime shot using ISO 100, f/3.5 and an eight-minute exposure. Less moonlight requires longer exposures, but, it's not a linear equation. In other words, you can't just do the math to figure out how much time is necessary; you have to experiment.

Be aware of any external artificial light such as lamp posts, street lights, or even the ambient glow from nearby cities. Even the dimmest light can end up appearing much brighter than you want it to in the final exposure, sometimes to the point of ruining the photo if your exposure time is particularly long. Another long exposure trick that is often used for photographing buildings in near darkness is to make the exposure so long that cars and people passing by don't register. This can be done at night or early morning, but will look like it was photographed in broad daylight with no one around.

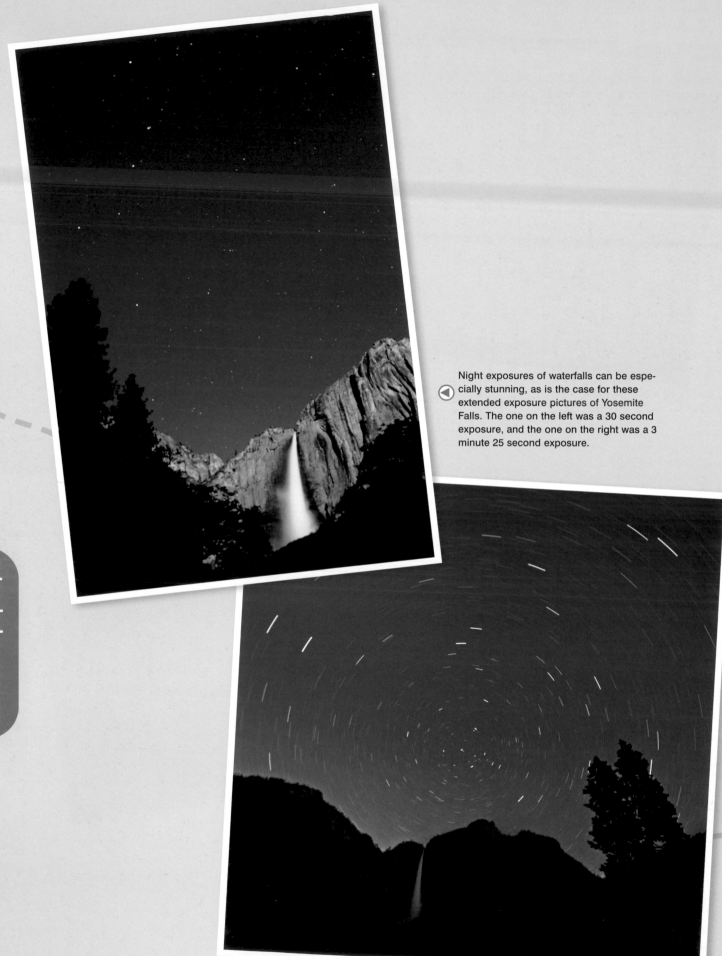

Night exposures of waterfalls can be espe-
cially stunning, as is the case for these
extended exposure pictures of Yosemite
Falls. The one on the left was a 30 second
exposure, and the one on the right was a 3
minute 25 second exposure.

extended exposures

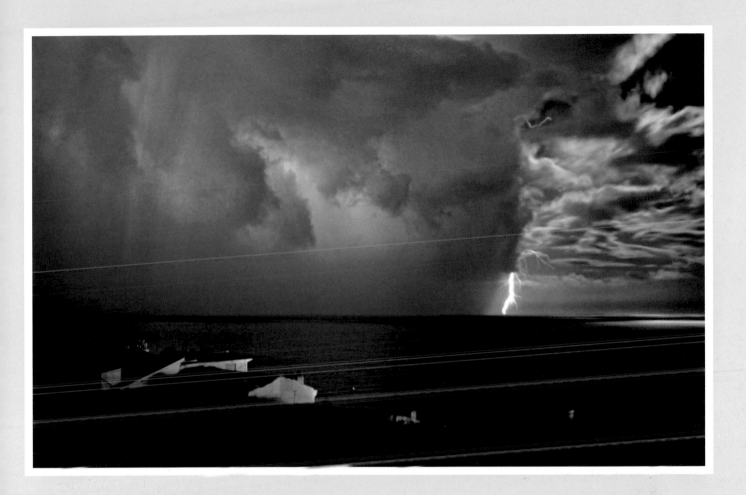

Lightning

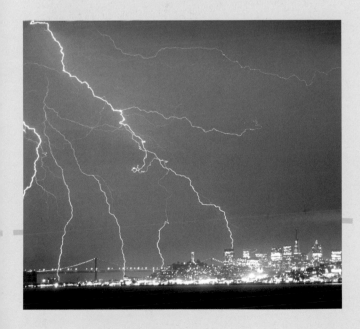

There's nothing like letting nature do the "heavy lifting" to add creative spin. Obviously, lightning's dramatic effect is worthwhile, but don't just set up your tripod in the direction of a lightning storm and hope to get good shots. Compose as though you were photographing any landscape, whether a cityscape or a natural backdrop. I just set the camera up (where it wasn't raining), pressed the button on the cable release, and waited anywhere from 5-10 minutes, depending on whether (or how much) lighting would strike. Meter to set exposure times similar to that of fireworks. The frequency of the lightning will affect the overall exposure, and there are no guidelines (other than experimentation) for how much exposure time you should allow.

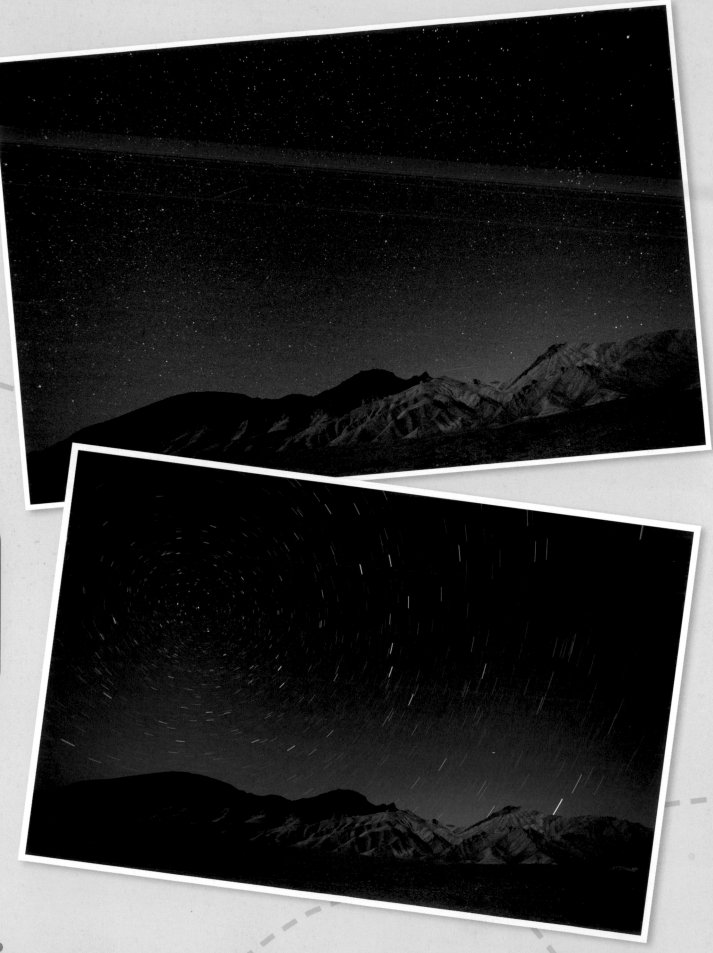

Photographing Star Trails

When photographing stars, you can either get a star "field," a static snapshot of the stars as points of light, or you can record star "trails." In this case, the earth's movement causes the camera to record streaks across the sky. How long you expose the image determines what you get. The first rule of thumb to remember is that it takes about 30 or 40 seconds to record a trail. (Recording the "movement" is largely dependent on your lens—the longer the focal length, the more apparent the movement; with wider angle lenses need more time to show the movement because the star point is so small.) Part of your experimentation will be to gauge the timing for how much "trail" you want.

Photographing star trails is technically simple; the main things to consider are:

√ What timing is best for the light and effect you want?

√ What are the most successful ways to compose the scene?

√ How do the limitations of battery power affect results?

√ How do you achieve different effects?

Most people shooting star trails start with wanting to capture the biggest trails they can by keeping the shutter open longer. The problem inherent in this is underestimating the ambient light in the sky, because you don't necessarily see it. This light may come from nearby cities, the moon, or even light from the sun for up to an hour or more after it sets. What your eye perceives is nothing compared to what's recorded by the long exposure of a camera. It can register so much residual ambient light that you won't see any stars at all. A 20-minute exposure made an hour after sunset can look like a day shot, and if the moon is more than a crescent, you'll be limited to just a few minutes at best. By comparison, a full moon will make a night shot look like a day shot in about 8 minutes at f/3.5 and an ISO setting of 100 (though this can vary depending on other climate conditions).

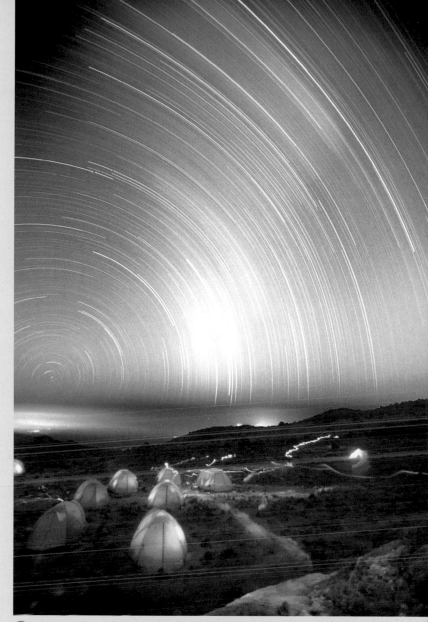

This is my very first truly successful star trails picture, a 3.5-hour exposure on a night with no moon, 16,000 feet above sea level at Mt. Kilimanjaro.

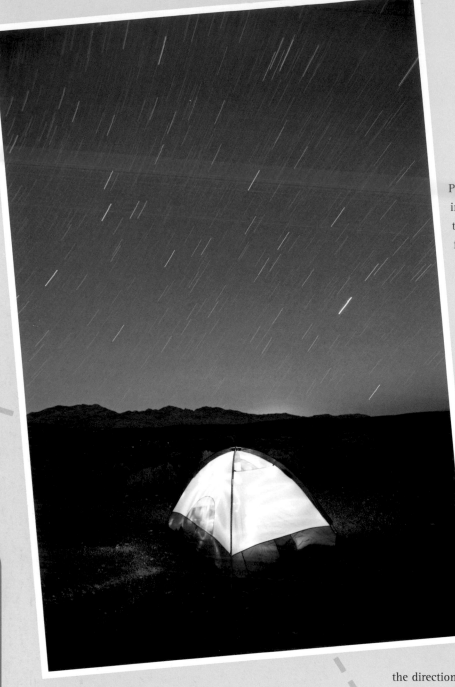

I waved a flashlight around inside a tent for about 30 seconds of this near 20-minute exposure.

Picking a faraway place on a night with no moon in sight is best for getting the darkest sky, making the light from the stars more pronounced. (Wait for the new moon cycle, or shoot before the moon rises or after it sets.) This may not be as easy as it sounds. The photograph of the lit tent (left) was shot in Death Valley over 300 miles away from Las Vegas, but the city still had an illuminating effect on the horizon. To make sure that the tent was illuminated, I spent about 30 seconds waving a flashlight around inside of it. This process is hard to get right without over-exposing the tent's fabric—a lesson learned from experimentation. This light also helped bring out detail on the ground.

While photos of nothing but star fields and trails are fascinating and will impress your friends and neighbors, they will get old pretty fast if that's the only thing in your photo. Star trail pictures are much better with foreground subjects. Think daytime photography here: a lake, an interesting tree, rock formation, or even your house. As you experiment with various shots, the first thing that'll pop out at you as you view the results, is the direction of the star trails themselves. This is never apparent when shooting the picture because you don't actually see the earth rotate. Hence, as you gain experience, the direction of the trails will become an increasingly important element in setting up your compositions.

On a perfectly dark night under a totally new moon, you won't see much other than stars. With no other light at all—even ambient light—you can't see other objects in the foreground, which makes for limited composition options. Here, it's common to get a silhouette of a tree or a mountain. It's also fun to use a flashlight to illuminate foreground subjects

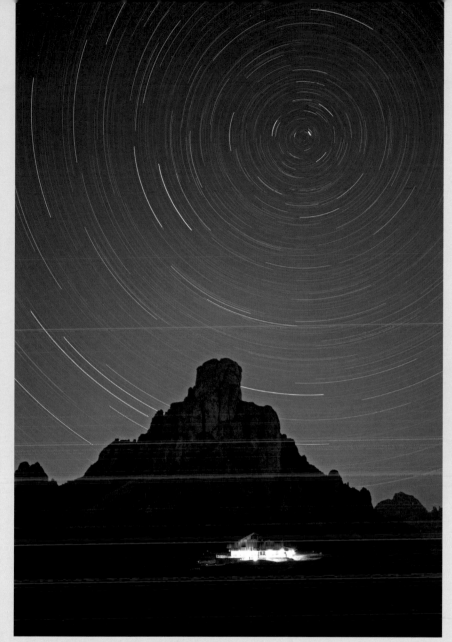

I shot this two hour exposure out a hotel room window in Italy.

like a cactus. (I've even used the brake lights and turn signals from my car to create colorful red and yellow effects on foreground objects.) Starting an exposure while a crescent moon is just about to set can illuminate the foreground enough to have them lit adequately, while permitting the exposure to continue (and get longer trails) as it gets darker.

In the northern hemisphere, most people use Polaris, the star that marks the North Pole, as a point of reference for composition decisions. (If you are shooting in the southern hemisphere, use Sigma Octantis, the southern pole star.) As the Earth rotates, stars will appear to spin around it, as shown in the photo of Gusela Mountain, in the Italian Dolomites.

When working with foreground subjects, you'll need to make sure you get them in focus along with the distant stars, which often requires smaller apertures. This works against you because the smaller aperture means less light. Alas, your composition has trade-offs: composing a scene that uses a wide aperture, but still has interesting foreground subjects. Generally, I design scenes with the closest subject at least 10 feet in front of the lens, if not further. I also use a wide angle lens, so that I can get everything in focus at f/3.5 to f/5.6. I try to avoid apertures greater than f/8, which can yield a reasonable picture, if exposed for several hours or more. Again, I don't want to raise my ISO setting, because the digital noise becomes intolerable.

115

One reason why long exposures are difficult to capture successfully is that there are many things that can ruin your picture, like a late-night car driving where it shouldn't be.

Because of the different sources of light and the great effects subtle changes can have on a very long exposure, you can't really "calculate exposure times" here. The camera's light meter is irrelevant, especially for exposures that are going to be in minutes, if not hours. This requires setting the shooting mode to "bulb" and using a cable release. Some advanced cable releases have timers built into them, whereas manual versions require you to push the cable yourself. If you think that's not so bad, keep in mind that you're going to have to be around (and awake) in several hours when you want to release that button. Every camera manufacturer has different cable releases to choose from, but after having done this for awhile, I can speak from experience that having one with a timer is well-worth the money!

At this juncture, you must now experiment and rely on trial and error to learn the ropes. Just set up what you might think would work, release the shutter, and go get coffee or go to sleep. It's tempting to want to use a higher ISO setting to brighten photos due to the lower light conditions but, as we've discussed, the downside of higher ISO is higher noise. I use ISO 100 to keep the digital noise down, since it is more pronounced in darker areas of an image than lighter ones.

When preparing to take a long extended exposure, it's useful to take 30-second test shots of the scene using your camera's highest ISO value. This will help you quickly sample various compositions and check for unwanted distractions (such as a branch at the edge of the frame) that the camera can see but your eyes can't. Once you've nailed down the desired composition, turn the ISO back to 100 and begin the long exposure.

Almost any film-based SLR will expose long enough because battery consumption is low. However, digital cameras have a tougher time because digital sensors eat power. Because of this, most digital cameras won't do much more than 30-40 minutes on a single charge, regardless of the battery type or camera model. It therefore becomes part of the evening's landscape choice to find a location where you can use your power cable. When staying in hotels, I often choose rooms that face towards the darkest part of the sky and that have the least amount of ambient light (usually the decorative hotel lights). This way, I plug into the wall, and place the camera (on tripod) either on the balcony, or shoot through the window. When camping, I use an AC power adaptor plugged into the car or a nearby power supply (a house, cabin, etc.) Obviously, this may not always be possible. In this case, true night-photo nuts go out and buy generators or battery packs that can keep a long exposure going for quite some time. To get more images in less time—and to make the most of battery power if you're not using a power adaptor—opt for simpler night pictures of shorter star trails, or just star fields. As stationary objects, it's still a pretty amazing site.

A common problem with night photography is dew fogging the glass because ambient air is warmer than the lens itself. What causes dew is the amount of humidity in the air (though cold fronts tend to have drier air). Metal lenses will always be colder than the ambient temperature, but even lenses with plastic barrels can suffer from the problem simply because of the glass components inside the lens. The solution is keep the lens warmer than the air. How you do that is the challenge. The most fool-proof way is to get a bulky battery pack and wire it up to your lens. Places that sell astronomy equipment make these for larger telescopes, but they are too large for normal camera equipment—it'd be like shooting a mouse with an elephant gun. The solution "works" and won't damage anything, but it's overkill.

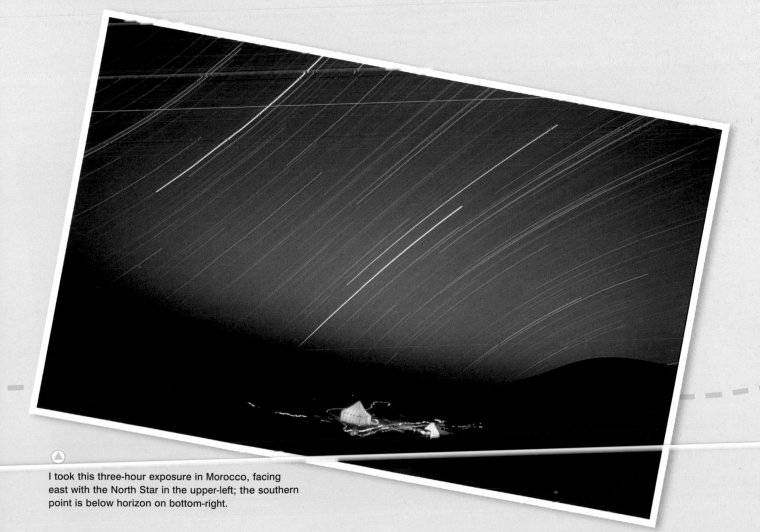

I took this three-hour exposure in Morocco, facing east with the North Star in the upper-left; the southern point is below horizon on bottom-right.

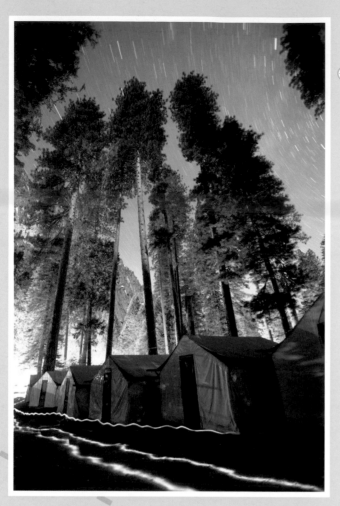

Light trails on the ground were from the flashlights of people walking by.

A more common and inexpensive way to prevent condensation from building up on the glass is to use one of those hand-warmers that you put inside gloves or boots for winter activities, like skiing. Wrap one or two around your lens with a rubber band, and it'll last anywhere from four to eight hours. Of course, if it's really humid, like at the top of mountains in Peru, where clouds hover around your tent, it's darn near impossible to avoid the dew.

This was a 20-minute exposure, with the trees lit by faint ambient light from the campfire.

Lighting for
Extended Exposures

If you are shooting a subject in motion or shooting from a moving object, flash is a very effective way to freeze a moment in time while still relaying a sense of motion. The flash only affects the foreground (because flashes are often limited to about ten feet), so compose the photo accordingly and do not expect the flash to light far-away objects. As for the foreground, even if ambient light registers as motion blur, chances are that the flash exposure will be more prominent. The taxicab photo (above) is a good example of this, but other common uses are shooting bands in concert, or people dancing (as seen on page 120). The flash will capture a still image, while the extended ambient light exposure (ranging from 1/8 of a second to several seconds) will add the feeling of movement to evoke a sense of what's going on.

If you want to have realistic looking motion blurs, however, you need a camera/flash combination that supports rear or second-curtain sync. This causes the camera to fire the flash at the end of the exposure, as opposed to normal sync, which fires it at the very beginning. Because rear sync fires the flash at the end of the exposure, it freezes the subject at the most forward part of its motion so that the trails, naturally, appear to follow behind it. Otherwise, the picture will look "backward," with the trails preceding the frozen subject, which simply doesn't work.

You can use multiple flash discharges creatively during long exposures, for example, by going inside a building and manually firing the flash. The trick is to put the flash in manual mode and direct it away from the camera toward a wall or an object that faces it. (Again, remember the ten-foot rule—most flash units aren't strong enough to illuminate objects further away.)

You should typically discharge the flash several times from inside a structure to make it appear that its interior is lit. The example here uses a flash covered by a red "gel" (over-sized filter). This technique requires some experimentation to get right, but the effect is pretty, not to mention unique.

120

With enough time and creativity, you can really go hog wild. For this photo of a "junker" 1930s Buick, I placed a flashlight covered with a blue gel inside the car. After a little while, I turned it off, and placed it inside each headlight of the car.

For larger spaces, or for use on building exteriors, consider buying one of those mammoth-sized spotlights from a home-improvement store. (Be sure to get one with a self-contained rechargeable battery.) For this photo, I "painted" the exterior of the church with a spotlight just as though I had a real paintbrush, covering the building from top to bottom by moving the spotlight around. It only took about 30 seconds to "paint" the building with light, but the entire exposure was about 7 minutes long.

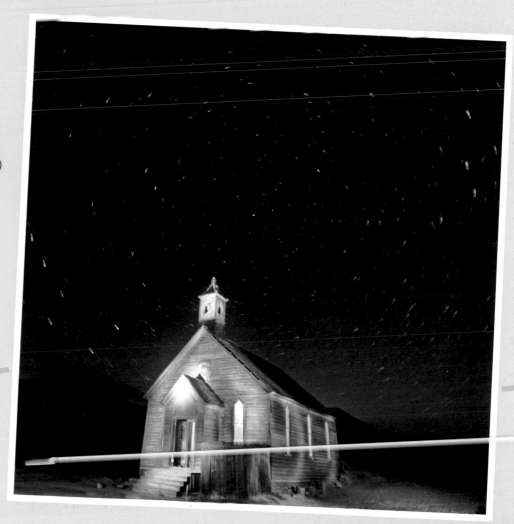

In this photo, I "painted" each side of the house with the spotlight (as with the picture on page 121), but this time, I used a red gel for the side and a blue gel for the front. The exposure time was well over an hour and a half, but it only took two minutes to paint it with light.

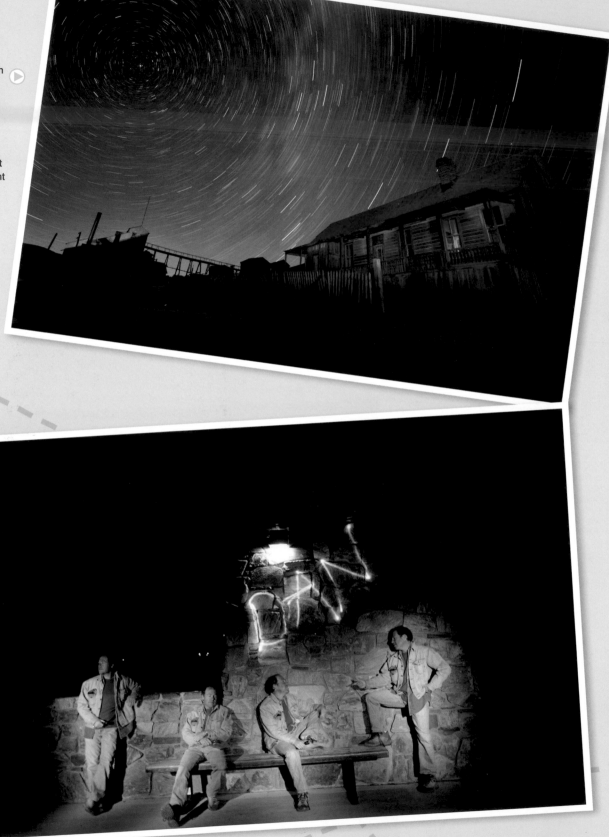

If you really get bored at 3 a.m., try self-portraits! For this single picture (lasting 54 seconds), I started by "writing" my name on the wall with a small pen-style flashlight. Then, I sat on the bench and had a friend burst a normal camera flash my way four times as I moved from one side of the frame to the other. Again, this sort of thing requires extensive experimentation so that you don't overlap yourself.

On the technical side, these techniques are no different than any other form of extended exposure photography. The creative aspect is finding interesting subjects and figuring out how (or whether) to light them. Experimentation goes a long way.

If you don't have a strong flashlight, try using the tail-lights of your car. That's how I lit the cactus in this image.

Index

index